Rain of the Moon
Silver in Ancient Peru

The sun rains gold
The moon rains silver

—Inka invocation

Rain of the Moon

Silver in Ancient Peru

HEIDI KING

with contributions by

LUIS JAIME CASTILLO BUTTERS *and*

PALOMA CARCEDO DE MUFARECH

The Metropolitan Museum of Art

Yale University Press

This catalogue is published in conjunction with the exhibition "Rain of the Moon: Silver in Ancient Peru," held at The Metropolitan Museum of Art, New York, November 3, 2000–April 22, 2001.

The exhibition is made possible by The Andrew W. Mellon Foundation.

The exhibition catalogue is made possible, in part, by the Roswell L. Gilpatric Fund for Publications.

Published by The Metropolitan Museum of Art, New York

John P. O'Neill, Editor in Chief
Emily Walter, Editor
Robert Weisberg, Design and Typesetting
Peter Antony and Megan Arney, Production

The essays by Luis Jaime Castillo Butters and Paloma Carcedo de Mufarech were translated from the Spanish by Debra Nagao. The bibliography was edited by Jayne Kuchna.

New photography by Paul Lachenauer and Eileen Travell, The Photograph Studio, The Metropolitan Museum of Art, New York

Map made by Adam Hart

Typeset in Centaur
Printed on 100 gms Centura Dull
Color separations by Professional Graphics, Inc., Rockford, Illinois
Printed and bound by Meridian Printing, East Greenwich, Rhode Island

Library of Congress Cataloging-in-Publication Data

King, Heidi
 Rain of the moon : silver in Ancient Peru / Heidi King ; with contributions by Paloma Carcedo de Mufarech and Luis Jaime Castillo Butters
 p. cm.
 Catalog of an exhibition at the Metropolitan Museum of Art Nov. 3, 2000–Apr. 22, 2001.
 Includes bibliographical references.
 ISBN 0-87099-970-2 (pbk.) — ISBN 0-300-08512-5 (Yale University Press)
 1. Indian silverwork—Peru—Exhibitions. I. Carcedo, Paloma. II. Castillo, Luis Jaime. III. Title.

F3429.3.S54 K55 2000
739.2'3'08998—dc21

 00-062496

Front cover illustration: Panpiper vessel. North Coast. Chimú, 14th–15th century. The Metropolitan Museum of Art (cat. no. 12)

Back cover illustration: Double-walled beaker with repoussé decoration, detail. North Coast. Lambayeque (Sicán)/Chimú, 14th–15th century. Denver Art Museum (cat. no. 7)

Contents

List of Lenders

The numbers listed below refer to works in the checklist.

American Museum of Natural History, New York 8, 15, 58, 59,
 61, 73, 74, 77, 82

The Art Museum, Princeton University 12–14, 52

Brooklyn Museum of Art 30, 66

Eugene Chesrow 20

The Cleveland Museum of Art 53, 54, 81

Dallas Museum of Art 65

Denver Art Museum 17, 18, 33, 43

Dumbarton Oaks, Washington, D.C. 39, 72

The Glassell Collection 9

Krannert Art Museum, University of Illinois, Urbana-Champaign
 16, 49–51, 55, 64, 70

Lowe Art Museum, University of Miami, Coral Gables 38

Museo Nacional de Historia Natural, Santiago 71

The Museum of Fine Arts, Houston 44, 67

Peabody Museum of Archaeology and Ethnology, Harvard
 University, Cambridge, Massachusetts 19, 46, 47

Perez Soto Collection 36, 56, 62, 68, 69, 83

Private Collections 2, 57, 75, 79, 80, 84

Director's Foreword

This exhibition, "Rain of the Moon: Silver in Ancient Peru," presents a little-known aspect of the ancient Peruvian world. It covers a period of nearly two thousand years, from the late first millennium B.C., when silver first appeared in small personal adornments, until the Spanish conquest in the sixteenth century, by which time it was worked into sizable objects for the exclusive use of the nobility. Over this time span a number of cultures developed along the Pacific coast of Peru and in the highland region of the Andes. The Vicús people, the Moche, the Lambayeque, the Chimú, and the Inka created works in silver that demonstrate their artistic creativity and technological ingenuity. While today gold commands more attention than silver because it is more highly valued, silver was to the ancients equally cherished and revered. Precious metals had no monetary value; rather, they were appreciated for their beauty and for their symbolic association with the sun and the moon, deities worshiped for their life-sustaining gifts. The title of the exhibition derives from an invocation chanted by tillers working the fields: "The sun rains gold, the moon rains silver."

The first exhibition devoted solely to the subject of Precolumbian Peruvian silver, it was initiated as part of a larger project on Peruvian silver from its beginnings until the present day. That exhibition, conceived by The Americas Society, New York, could not be realized as planned, but we are pleased to be able to bring a segment of it to fruition.

Nearly half of the more than one hundred works in the exhibition are drawn from the Museum's holdings, in both range and quality the strongest collection of ancient Peruvian silver in the United States. This is primarily thanks to the collections of Nelson A. Rockefeller and Arnold I. Goldberg, which were formed in the 1960s and early 1970s and subsequently bequeathed to the Museum. The scope of the exhibition has been further enriched through the generous loans of major public institutions and private collectors in the United States and Chile. I am indebted to those lenders for their participation. The Museum also thanks, in particular, the Denver Art Museum for lending, and allowing us to publish for the first time, two spectacular ritual drinking vessels covered with complex narrative scenes. We are especially grateful to the American Museum of Natural History, New York, for making ten of their finest pieces in silver, all on permanent display in their galleries, available for the exhibition, including the famous long-haired Inka llama. The exhibition affords the Metropolitan Museum the opportunity to show its own collection in a different context. Our impressive group of Chimú silver, usually on view in the Jan Mitchell Treasury, will be reunited with other works now in various museum collections that formed part of the same discovery.

For the organization of the exhibition and for lending her knowledge and expertise to the writing of the catalogue, I wish to thank Heidi King, Research Associate in the Department of the Arts of Africa, Oceania, and the Americas. And for their contributions to the catalogue we are grateful to two Peruvian scholars, Luis Jaime Castillo Butters and Paloma Carcedo de Mufarech, both of the Pontificia Universidad Católica, Lima. The Museum is grateful to The Andrew W. Mellon Foundation for its generous support of the exhibition. The realization of the accompanying exhibition catalogue is made possible, in part, by the Roswell L. Gilpatric Fund for Publications.

Philippe de Montebello
Director
The Metropolitan Museum of Art

Acknowledgments

During the course of this project I have benefited greatly from the help of many individuals and from their generosity in extending to me their knowledge and expertise. I would like first to thank The Americas Society, New York, which conceived the idea of an exhibition on Peruvian silver and generously funded the initial research for the project. It was a pleasure to work with the gracious and friendly staff at the Society in the early stages.

I am deeply grateful for the kindness and cooperation I received from my colleagues at the museums I visited in connection with the exhibition, all of whom made the resources of their institutions available and facilitated the loans to the exhibition. I am particularly indebted to Craig Morris and Sumru Aricanli of the Department of Anthropology at the American Museum of Natural History, New York; Margaret Young-Sanchez at the Denver Art Museum; Gloria Greis and Genevieve Fisher at the Peabody Museum of Archaeology and Ethnology at Harvard University; Eunice Dauterman Maguire and Kathleen Jones at the Krannert Art Museum, University of Illinois; Frances Marzio and Anne Schaffer at the Museum of Fine Art, Houston; Loa Traxler at Dumbarton Oaks, Washington, D.C.; Gillett Griffin and Matthew Robb at The Art Museum, Princeton University; Diana Fane and Susan Zeller at the Brooklyn Museum of Art; Carol Robbins at the Dallas Museum of Art; Brian Dursum at the Lowe Art Museum, University of Miami; and Carol Ciulla and Bruce Christman at The Cleveland Museum of Art.

A number of scholars and museum professionals were most generous with their counsel, providing invaluable information and guiding me to important works. Among those I wish to thank are Warwick Bray, Susan Bruce, Richard Burger, Mary Frame, Maarten van de Guchte, Michael Kan, Emily Kaplan, Heather Lechtman, Joanne Pillsbury, Ann Rowe, Gary Urton, and Michael Whittington. My gratitude extends also to my colleagues Susan Bergh and Wendy Schonfeld for reading parts of the manuscript and for their perceptive comments and suggestions. Many discussions with Ellen Howe on complex issues involving ancient Peruvian metallurgy were most informative; I thank her for sharing her knowledge and for her work on the objects. Two rollout photographs by Justin Kerr are a noteworthy contribution to the catalogue.

At the Metropolitan Museum I wish first to express my deep gratitude to Julie Jones, Curator in Charge of the Metropolitan's Department of the Arts of Africa, Oceania, and the Americas, for having entrusted me with the exhibition when it came to the Museum. Her patient guidance and unfailing support, her many suggestions, and her long experience in the museum world provided invaluable insights in all aspects of the project. Many individuals of several departments contributed their skills and special talents to the exhibition and to the catalogue. It was a pleasure to work with all of them. Under the efficient supervision of Aileen Chuk of the Registrar's Office the objects were brought safely into the Museum. Many required treatment before being exhibited, which was carried out by the able staff of the Department of Objects Conservation. I am particularly grateful to Richard Stone, Leslie Gat, Christine Giuntini, Hermes Knauer, George Wheeler, and Mark Wypyski for their contributions and for their patience in answering my many questions. Nancy Reynolds and Alexandra Walcott created handsome mounts for the display of the objects, and Dennis Kois designed the installation.

The experience and professionalism of the staff of the Editorial Department, under the guidance of John P. O'Neill, is evident in this publication. Foremost I thank my editor, Emily Walter, whose dedication, limitless patience, and support, as well as her enthusiasm and sincere interest in the subject, are reflected in the text. The elegant presentation is the work of Peter Antony and Megan Arney, Production, and of Robert Weisberg, who created the attractive design. Paul Lachenauer and Eileen Travell, of the Museum's Photograph Studio, are responsible for the fine photographs. Jayne Kuchna performed the painstaking task of editing the bibliographical citations. And Adam Hart produced the useful and detailed map.

I wish also to thank my colleagues in the Department of the Arts of Africa, Oceania, and the Americas, particularly Ross Day of the Robert Goldwater Library and his staff, who greatly facilitated my research during the project.

Finally, I thank my husband, Timothy, who never tires of encouraging me, listening patiently to daily progress reports, and sharing my joy in the subject.

Chronology

Note: Dates cited are approximate.

Archaeological Periods	Years	North Coast	Central Coast	South Coast	North Highlands	Central Highlands	South Highlands
	(A.D.)						
	1600						
Late Horizon 1450–1534	1500	INKA 1450–1534	INKA 1450–1534	INKA 1450–1534	INKA 1450–1534	INKA 1450–1534	INKA 1450–1534
	1400						
	1300	CHIMÚ 1100–1470					
Late Intermediate Period 1000–1470	1200		CHANCAY 1000–1450	CHINCHA ICA 1100–1450			
	1100						
	1000	LAMBAYEQUE 800–1350					
	900						
Middle Horizon 600–1000	800						
	700		WARI 600–800	WARI 600–800		WARI 600–800	TIWANAKU 400 (?)–1000
	600						
	500	MOCHE 100–800					
	400						
	300	VICÚS 200 B.C.– A.D. 500			RECUAY 100–600		
Early Intermediate Period 200 B.C. – A.D. 600	200			NAZCA 100 B.C.– A.D. 600			
	100	SALINAR					
	—	VIRÚ (GALLINAZO) 200 B.C.– A.D. 200					
	100						
	200						
	300			PARACAS 700 B.C.– A.D. 100			
Early Horizon 600–200 B.C.	400						
	500	CUPISNIQUE 1200–200 B.C.					
	600				CHAVÍN 900–200 B.C.		
	700						
	800						
	900						
	1000						
	1100						
Initial Period 1800–600 B.C.	1200						
	(B.C.)						

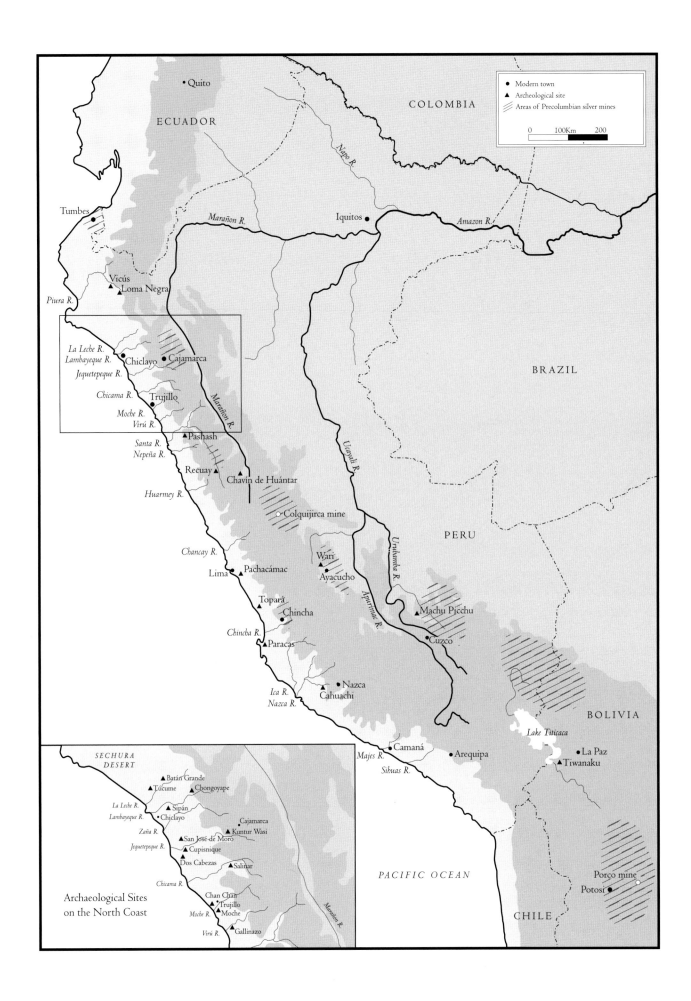

• Quito

COLOMBIA

ECUADOR

Napo R.

Marañon R. Iquitos • *Amazon R.*

Tumbes •

Piura R.

▲ Vicús
▲ Loma Negra

BRAZIL

La Leche R.
Lambayeque R. ● Chiclayo ● Cajamarca
Jequetepeque R.

Chicama R. ● Trujillo

Moche R.
Virú R.
▲ Pashash
Santa R.
Nepeña R.
Recuay ▲
▲ Chavín de Huántar

Marañon R.

Huarmey R.

○ Colquijirca mine

PERU

Chancay R. ▲ Wari
Lima ● ▲ Pachacámac ● Ayacucho

▲ Toparà
● Chincha ▲ Machu Picchu
Chincha R.
▲ Paracas ● Cuzco

Ica R. ▲ ● Nazca
Nazca R. Cahuachi

BOLIVIA

Lake Titicaca

Majes R. ▲ Camaná ● Arequipa ● La Paz
Sihuas R. ▲ Tiwanaku

Ucayali R.

Apurímac R.

Urubamba R.

● Modern town
▲ Archeological site
▨ Areas of Precolumbian silver mines

0 100Km 200

PACIFIC OCEAN

*SECHURA
DESERT*

▲ Batán Grande
▲ Túcume ▲ Chongoyape
La Leche R.
Lambayeque R. ▲ Sipán
 ● Chiclayo
Zaña R. ▲ Cajamarca
 ▲ San José de Moro ▲ Kuntur Wasi
Jequetepeque R. ▲ Cupisnique
 Dos Cabezas ▲ Salinar
Chicama R.
 ▲ Chan Chan
 ▲ Trujillo
Archaeological Sites ▲ Moche
on the North Coast *Moche R.*
 Virú R. ▲ Gallinazo

Porco mine ○
Potosí ●

CHILE

Introduction

HEIDI KING

The colors and glitter of precious metals have appealed to peoples of many cultures from time immemorial. In ancient Peruvian cultures precious metals had a special status. Gold and silver, symbols of power and prestige, also held religious significance. When the Spaniards arrived in Peru in the sixteenth century, they discovered a vast area stretching from central Chile to Ecuador ruled by the Inka.[1] They reported that all the gold and silver in the land was the property of the Inka (supreme ruler) and that these two metals were associated with celestial deities. The warm, reflective glow of gold symbolized the sun, a male deity; the soft, cool sheen of silver symbolized the moon, a female deity and source of life-giving waters. Workers tilling the fields would chant in Quechua, the language of the Inka, "¡inti qori paran, killa qolqe paran!" (The sun rains gold, the moon rains silver).[2]

Metal deposits are abundant in the Central Andean region. In ancient times they were most plentiful and accessible in the north: gold in the coastal riverbeds, copper and silver in the highlands. The majority of archaeological finds of precious metal objects made by ancient metalsmiths come from the northern coastal valleys, where Andean metallurgy reached its height of technical excellence and creativity. It was not until the late fifteenth century, when the Inka controlled the entire Central Andean region, that metals were also worked on a large scale in the south.

The primary metals used were gold, silver, and copper, and the preferred method of working them, particularly gold and silver, was by hammering. The metals were often alloyed—most commonly copper with gold, copper with silver, and silver with gold—both to achieve desired physical properties, such as a specific color, and to improve strength and malleability.

Gold was the first metal worked in the Andes—as early as the late second millennium B.C.—and because it is virtually indestructible, vast quantities of gold objects in good condition have been recovered from burials. Impressive numbers of copper works also survive, although they are usually not as well preserved. Objects made predominantly of silver are, by contrast, few and often in a poor state of preservation. Even taking into consideration the fact that silver, unlike gold, deteriorates easily when buried and exposed to the salts and minerals in soil, it would seem that there is little evidence that silver objects were ever present in many sites where items of gold and copper have been uncovered.[3] Thus, it appears that silver was less frequently worked, most likely because it was more difficult to locate and to process. Unlike gold, it does not occur as nuggets and flakes in alluvial surface deposits but in the veins of rocks, usually with other minerals, in

1. The Inka had no written language, and the traditional Spanish spelling of their name is with a *c*. However, many scholars now use the modern spelling in Quechua, in which a *k* is employed. The term "Inka" is used both as a name for the ethnic group and as a title for the supreme ruler of the Inka people (Morris and Hagen 1993, p. 9).

2. Lara 1980, p. 40. I am grateful to Susan Bergh for having brought this reference to my attention.

 It has often been said that the Inka thought of gold as "the sweat of the sun" and silver as "the tears of the moon" (Lothrop 1938, p. 20; Emmerich 1965, p. XIX; Muller 1985, p. 15, to name but a few authors). Despite extensive research in the literature of the sixteenth century, the original Quechua source of this expression remains unknown.

3. Personal communication, Luis Jaime Castillo Butters, March 2000.

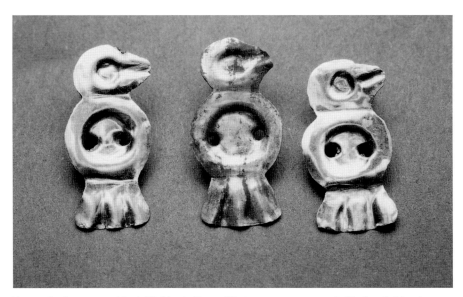

Figure 1. Bird ornaments. North Highlands. Kuntur Wasi, ca. 800–ca. 500 B.C. Gold, silver, height 1 in. (2.5 cm). Kuntur Wasi Museum (photo: Yoshio Onuki and Yutaka Yosii)

4. Onuki 1995.
5. There are several hundred objects in The Metropolitan Museum of Art made of copper that are now covered with a thick layer of green corrosion. Among those analyzed in the Museum's Sherman Fairchild Center for Objects Conservation, a substantial number were found to have been silvered (Schorsch, Howe, and Wypyski 1996, pp. 145–63). They are from the Moche site of Loma Negra, in the Piura Valley, near the Ecuadoran border.
6. For a detailed discussion of metalworking technologies developed by ancient Peruvians, see Lechtman 1977, pp. 3–20; Lechtman 1984, pp. 1–36; and Lechtman 1988, pp. 344–78.
7. Schorsch 1998, pp. 109–36.
8. Alva and Donnan 1993, pp. 221–23.
9. The Lambayeque culture was first named by the Peruvian archaeologist Larco Hoyle (1948, pp. 43–45). Recent archaeological investigations, particularly in the area of Batán Grande, have allowed for a better understanding of the culture, which is now sometimes referred to as "Sicán," the indigenous name for Batán Grande, its presumed capital (Carcedo de Mufarech and Shimada 1985, p. 62; see also Shimada 1985, p. 92). Although "Sicán" is used by some scholars, the majority of researchers prefer "Lambayeque,"

inaccessible mountainous regions. It cannot be worked as found but must first be smelted—separated from other minerals—and refined.

Among the earliest silver objects from Peru are small bird ornaments—probably used to adorn textiles—cut from hammered sheet (fig. 1) and beads made in two halves, also from sheet, and joined, probably by welding, at the midsection. Excavated at the site of Kuntur Wasi, near the modern town of Cajamarca, in the North Highlands, they are dated to the middle of the first millennium B.C.[4] More than five hundred years later, the Moche, who controlled the northern seacoast for seven hundred years, from about 100 to 800, produced enormous quantities of personal ornaments and ceremonial objects made of precious metals, among them earflares, nose ornaments, pectorals, headdresses, scepters, and ritual knives. These objects of gold and silver were worn and used exclusively by the elite, whose social status and political authority they expressed in life as they did in death when placed as offerings in tombs. Excavations made from 1987 to the early 1990s of several burials of Moche lords at the site of Sipán, near the coastal town of Chiclayo, yielded an extraordinary array of exquisite personal finery, mostly in gold and gilt copper; a comparatively small number of objects were of silver and silvered copper.[5] The Moche mastered most of the metalworking techniques practiced in the Andes, including lost-wax casting and the gilding and silvering of copper.[6] They also combined silver with gold in the same ornament, using sophisticated mechanical and metallurgical joining methods,[7] perhaps for ideological purposes.[8]

About the middle of the first millennium A.D., when Moche power on the North Coast began to weaken, there seems to have been a dramatic decline in the use of precious metals. It was not until about the ninth century, when the Lambayeque culture (also called Sicán, ca. 850–ca. 1300)[9] and subsequently the Chimú (ca. 1100–ca. 1470) rose to prominence on the North Coast, that metalworking resumed on a large scale. Indeed, the number of metal objects, primarily gold, gilt copper,

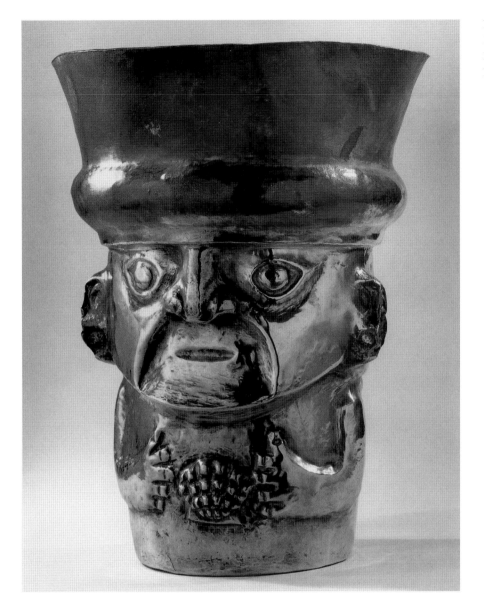

Figure 2. Beaker. North Coast. Lambayeque, 10th–11th century. Silver, height 10⅞ in. (27.6 cm). Brooklyn Museum of Art

and copper, found in tombs of high-ranking individuals of this period is unprecedented in the Andes. One Lambayeque burial at Batán Grande, in the La Leche Valley, contained more than a ton of burial goods, most of them of metal.[10] Silver production also increased at this time, perhaps because of better access to silver deposits or improved metal processing skills. The majority of silver objects now preserved in collections date from this period or later (ca. 900–1532). They are grand, flamboyant, and often of large size.

In this later phase of Peruvian prehistory, it would appear that precious metal was in general put to different use than it had been in earlier centuries (ca. 500 B.C.–ca. A.D. 600), when it was predominantly crafted into items of personal adornment for the elite. While jewelry, especially elaborate headdresses, earspools, and textile ornaments continued to be made,[11] metal tomb offerings were increasingly in the form of vessels, most commonly beakers.[12] Vessels with flaring walls and embossed faces are particularly characteristic of the Lambayeque culture (fig. 2). One royal tomb from this period is reported to have included one hundred seventy-six

the earliest name that appeared in print.

10. Shimada 1997, p. 51.

11. Nose ornaments, for many centuries an essential part of the stately attire of powerful men in Peruvian cultures, are very rare after about A.D. 800.

12. The earlier Moche (ca. 100–ca. 800) did not use precious metals to create vessels. In fact, excavations in recent years of important Moche burials on the North Coast have not yielded any vessels made of gold or silver (Alva and Donnan at Sipán [1993]; Castillo Butters and Donnan at San José de Moro [1994, pp. 93–146]; and Donnan at Dos Cabezas [forthcoming]).

Fragmentary remains of ceremonial goblets in copper have, however, been found in the tombs of the priestesses at San José de Moro (Castillo Butters, personal communication, March 2000). It has been suggested that these copper goblets were used in the Sacrifice Ceremony (Donnan 1976, pp. 117–29, and Donnan and Castillo Butters 1994, pp. 415–24).

13. Carcedo de Mufarech and Shimada 1985, p. 62.

14. Heyerdahl, Sandweiss, and Narváez 1995, pp. 111–12.

beakers in gold and silver.[13] Also at this time the peoples of the North and Central Coasts produced large numbers of miniature objects in silver and silvered copper, among them multifigured scenes of daily life (fig. 3). These too were preserved in tombs or caches (see cat. nos. 19–22). A recently excavated offering at Túcume, northeast of Chiclayo, contained hundreds of such objects—diminutive musical instruments, agricultural and weaving tools, weapons, and a variety of vessels.[14]

In the second half of the fifteenth century the Inka, who ruled for less than a hundred years, from about 1450 to 1532, conquered the Chimú on the North Coast. Impressed by the quality of the precious metal objects made for the Chimú nobility, the Inka relocated the most skilled metalsmiths from the coast to Cuzco, the capital in the South Highlands. The splendor of the gold and silver works that embellished the sacred shrines and royal palaces and gardens in Cuzco in the sixteenth century is known from descriptions written by the Spaniards, who had arrived from Europe in the newly discovered lands. Pedro de Cieza de León, a Spanish soldier who went to Peru in 1547, wrote the following:

> Nowhere in this kingdom of Peru was there a city with the air of nobility that Cuzco possessed. . . . There was the imposing temple to the sun, which they called Curicancha [the Golden Enclosure], which was among the richest in gold and silver to be found anywhere in the world. . . . In one of

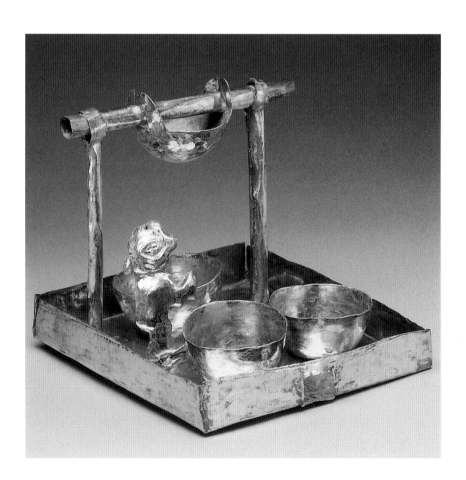

Figure 3. Model showing the manufacture of *chicha*, fermented beverages, North-Central Coast. Chimú or Chancay, 13th–15th century. Silver, height 3¼ in. (8.3 cm). Krannert Art Museum, University of Illinois, Urbana-Champaign

[the] houses, which was the richest, there was an image of the sun, of great size, made of gold, beautifully wrought and set with many precious stones. . . . There was a garden in which the earth was lumps of fine gold, and it was cunningly planted with stalks of corn that were of gold—stalk, leaves, and ears. . . . Aside from this, there were more than twenty sheep of gold with their lambs, and the shepherds who guarded them, with their slings and staffs, all of this metal. There were many tubs of gold and silver and emeralds, and goblets, pots, and every kind of vessel all of fine gold. . . . In a word, it was one of the richest temples in the whole world.[15]

15. Cieza de León 1959, pp. 144–47.
16. Ibid., p. 163.

He reported as well that the Inka controlled not only the production of metal objects but also the mining of precious metals throughout the empire:

So well had the Incas organized [production] that the amount of gold and silver mined throughout the kingdom was so great that there must have been years when they took over fifty thousand arrobas [633 tons] of silver, and over fifteen thousand [190 tons] of gold, and all this metal was for their use.[16]

The Spaniards arrived in Peru in 1532. Virtually all the gold and silver that came into their hands was melted down, and very little precious metalwork made by the Inka survives today. Mostly this is in the form of small votive figurines of men, women, and llamas in gold and in silver. Only occasionally are they found by archaeologists, primarily in inaccessible mountaintop sanctuaries, where they were buried by the Inka as offerings, with or without human remains, to honor the gods.

After plundering the gold and silver treasures from temples, shrines, and tombs, the Spaniards began to search for mines. Thousands of Indian mine workers were enslaved and subjected to appalling working conditions; most did not survive. Under the Spaniards, Indian metalsmiths were forced to apply their technical skills to make objects that were completely foreign to them to embellish the churches and homes of their new masters, and a native metalworking tradition of nearly three thousand years came to an abrupt end.

✳ ✳ ✳

The exhibition presents objects from most Peruvian cultures that worked silver in pre-European times. Because silver is a material that reacts chemically to its environment, the state of preservation was a major concern in the selection of the objects. The wide range in surface appearance is the result of two factors: first, the varying amounts of copper in the silver and the physiochemical changes that took place in the metal over many centuries of burial, and second, approaches concerning the conservation of archaeological metal objects. Some have undergone little or no treatment and appear almost as they were found; they do not look like silver because their surfaces have corroded through long exposure to moisture, salts, and other elements in the ground. In some instances, surfaces are covered with green corrosion products, which derive from large amounts of copper in the alloy, and others have turned to gray or black silver chloride. On still other objects, dirt and corrosion products have been partially or completely removed and the surfaces polished to produce a semblance of their original appearance.

The Evolution of Complex Societies in Ancient Peru

Luis Jaime Castillo Butters

The civilizations that arose in the Central Andes in the region of what is today the country of Peru from about 3000 B.C. until their conquest by the Spaniards in 1532–34 created some of the most remarkable art and architecture ever made. In these cultures art and technology enabled the ruling classes to exercise power through the judicious manipulation of ideology and the effective exploitation of natural resources.

Andean societies excelled in metallurgy.[1] The earliest evidence of goldwork, fashioned by the simple technique of hammering, appears about 1500 B.C. Gradually, techniques became more sophisticated and materials were combined, which resulted in an efficient use of gold and silver, the development of copper metallurgy, and higher levels of production.

The excellent state of preservation of archaeological remains on the Pacific coast of Peru, the result of the exceptionally dry weather and the fact of having been buried and thus not exposed to climatic changes, has made it possible for us to study fragile artifacts—above all, those made of silver, copper, and their alloys. Furthermore, many instruments used in the working of metal objects—hammers, polishers, smelting furnaces, matrices, molds, and crucibles—have also been preserved, which has encouraged the study of metallurgy in terms of production and manufacture.

Most of the objects in this exhibition were found on the North Coast of Peru, one of the most important centers for the development of metalwork. Many are quite elaborate, reflecting technical advancements and decorative variety. In the following pages, we shall deal with the rise of cultures on the North Coast within the context of the general history of pre-Hispanic societies.

Civilization developed in the Central Andes in two distinct regions, the coast and the highlands; thus, its evolution depended on adaptation to two very different but complementary environments. The coast of Peru is a narrow, arid strip of land situated between the mountain range of the Andes and the Pacific Ocean. There is an almost perpetual lack of rain. The riverbeds are completely dry during a large part of the year, and it is only during the rainy season in the highlands, between the months of November and March, that water reaches the coast, in the form of torrential rivers that course from the mountains to the sea. Unlike the coastal regions, the immediate shores of the Pacific Ocean possess an enormous wealth of natural resources and marine life.

Characterized by contrasts in elevation and climate, the highlands foster a variety of flora and fauna. The first spurs of the Andes appear a few miles from the

1. Carcedo de Mufarech 1997.

16

coast, where the mountains rise abruptly to great heights of several thousand feet. If aridity is the great challenge in the coastal regions, in the highlands it is an irregular topography with high mountains, deep valleys, and churning rivers, in addition to unstable rainfall, frequent frosts, and landslides. Here communities evolved in isolated areas, which encouraged the development of local traditions. Similarly, the adaptation of plant and animal species to different altitudes required land-use strategies dramatically different from those applied in the less variable lowlands. Highland communities also needed to maintain trade with lowland communities to ensure access to a wide range of natural resources.

To explain the development of civilizations in Peru, archaeologists use a system borrowed from the study of prehistoric Egypt in which each of three periods of consolidation, called Horizons, is followed by a phase of cultural fragmentation, called an Intermediate Period.[2] It should be noted that these interpretations of cultural evolution are constantly being refined on the basis of new research and documented findings which allow us to better understand the people of the region and their interaction with neighboring societies.

Although evidence of cultural complexity appears very early in Peru, in the first millennium B.C., particularly on the coast, it is not until about 1500 B.C. that the formation of civilization begins. Grouped around ceremonial centers where religious activities were performed, the farming communities that were established appear to have had an efficient agriculture and sufficient resources to enable them to be self-sustaining. Such communities produced textile art of cotton and wool, the earliest examples of goldwork, and codified artistic expressions. From about 600 to about 200 B.C., during the Early Horizon (also known as the Chavín or Formative Period), the foundations were laid for the development of cultures that would share a common iconography with recurrent religious themes. This iconography is seen on the polished black ceramics made at this time (fig. 4). Societies then diversified in the Early Intermediate Period (ca. 200 B.C.–ca. A.D. 600), when states with their own identities begin to emerge.

In metallurgy it is during the Early Intermediate Period that the majority of techniques used in later periods are developed. The coastal regions express their individuality in distinctive art styles, apparently one result of the creation of the first states, including the Vicús, Moche, Virú (Gallinazo), and Nazca cultures. An era of stylistic consolidation follows in the Middle Horizon (ca. 600–ca. 1000), specifically in the art of ceramics. Although the political interactions between these cultures are debated among scholars, it is evident that the most important iconography of the period derives from the highland societies in the south, particularly the powerful Wari culture.

During the Late Intermediate Period (ca. 1000–ca. 1470), various peoples with new cultural symbols and artistic forms and expressions, notably blackware ceramics, gained ascendancy on the coast—the Lambayeque and the Chimú in the north, the Chancay on the Central Coast, and the Chincha in the south. Finally, during the

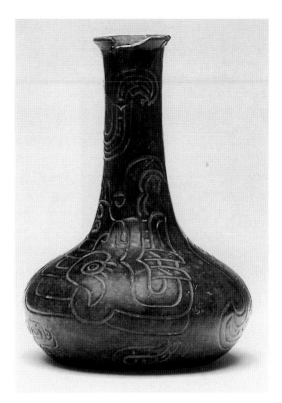

Figure 4. Incised bottle with the face of a fanged deity. Chavín, 900–400 B.C. Blackware, height 8⅛ in. (20.6 cm). Museo Arqueológico de la Universidad Nacional Mayor de San Marcos, Lima (photo: Dirk Antrop)

2. The chronology of Central Andean prehistory used throughout this catalogue is based on Moseley 1992, pp. 16–22: Initial Period, ca. 1800–ca. 600 B.C.; Early Horizon, ca. 600–ca. 200 B.C.; Early Intermediate Period, ca. 200 B.C.–ca. A.D. 600; Middle Horizon, ca. 600–ca. 1000; Late Intermediate Period, ca. 1000–ca. 1470; Late Horizon, ca. 1450–1534.

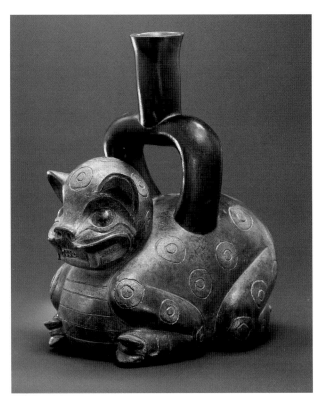

Figure 5. Stirrup-spout bottle. North Coast. Cupisnique, ca. 1200–ca.200 B.C. Blackware, height 9⅛ in. (23.2 cm). The Metropolitan Museum of Art, The Michael C. Rockefeller Memorial Collection, Purchase, Nelson A. Rockefeller Gift, 1968 1978.412.217

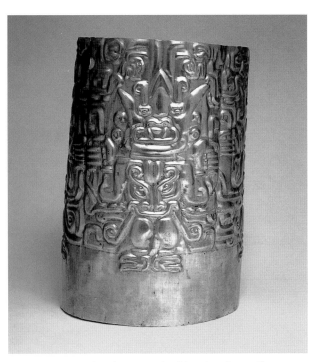

Figure 6. Crown with anthropomorphic feline deity figure. Chavín, reportedly from Chongoyape, Lambayeque Valley, ca. 800–ca. 200 B.C. Hammered gold, height 9½ in. (24 cm). National Museum of the American Indian, Smithsonian Institution, Washington, D.C.

Late Horizon (ca. 1450–1534), the entire coast and highlands of Peru and a vast extension of regions that today comprise Colombia, Ecuador, Bolivia, Argentina, and Chile were conquered by the Inka and integrated into the empire that they called Tawantinsuyo (Land of the Four Quarters). Under the Inka the Central Andes were united into a single political entity. Advances made by subjugated cultures were incorporated and cultural patterns consolidated. The ancient tradition of metallurgy was exceptionally strong in the north, the region dominated by the Chimú. This depth of metallurgic knowledge was then acquired and developed by the Inka.

THE EARLY HORIZON AND THE CUPISNIQUE CULTURE

The first civilizations on the coast evolved from the hunting and gathering societies that inhabited such regions as the Paiján desert, north of Trujillo, and the vast deserts of Piura. In these communities, animals such as dogs, llamas, and guinea pigs were domesticated and plants such as squash, beans, and cotton were cultivated. Permanent settlements grew up both in the highland valleys and on the coast, where marine resources (fish, mollusks, crabs, and algae) were the staples of the diet. Natural resources were successfully exploited and the population increased.[3]

In the middle of the second millennium B.C., communities now labeled Cupisnique arose along the rivers of the North Coast. These were the coastal manifestation of Chavín society.[4] Never forming a cultural entity, these small clusters of villages were governed by *caciques*, or chiefs, and were organized into clearly differentiated social classes. The constant hostilities between these communities may be explained by the continuous scarcity of natural resources. While they appear to be politically autonomous, they apparently shared a single cult, one perhaps based on rites practiced at the ceremonial center of Chavín de Huántar, in the North-Central Highlands. We see great variety in the art of ceramics during this period. Especially notable are the beautiful stirrup-spout bottles (fig. 5). The first techniques for the production and decoration of gold and other metal objects were also developed at

this time. Both ceramic and metal objects were embellished with complex designs of deities with wide eyes, large fangs, and claws (fig. 6), as well as mythological scenes, feline creatures, and individuals consuming hallucinogenic substances. The most important assemblage of artifacts was excavated from the tombs of Kuntur Wasi, in the North Highlands, near the town of Cajamarca.[5] Other significant finds were made in the valley of Jequetepeque and at Chongoyape, in Lambayeque.

The Early Intermediate Period, Moche Culture, and the Origins of the State

Over the centuries regional traditions emerged from the Cupisnique culture, and their specific characteristics were confined to individual communities. Noteworthy were the Vicús in Piura, the Salinar and the Virú on the North Coast, and the Paracas and Topará on the South Coast. While political organization under the rule of a *cacique* with limited territorial control appears to have continued, there was a proliferation of large public works such as ceremonial centers and elaborate and highly efficient irrigation systems. Toward the end of the first millennium B.C. these regional traditions again show signs of becoming homogeneous, as the smaller settlements combined to form larger regional communities. Eventually, two great cultures emerged on the coast, the Moche in the north and the Nazca in the south. The Moche, who controlled the entire North Coast between the valleys of Piura and Nepeña, established themselves in the first century A.D. and were to constitute the first society in the Central Andes that can be called a state with a technological and political foundation.

Like the preceding Cupisnique chiefdoms, the Moche states, while independent, were linked by cultural and religious ties. But the Moche states, which spanned many coastal valleys, were much larger in scale, comprising populations in the tens of thousands. They also made extensive technological advances. And although the Cupisnique were a ranked society, the Moche had a highly complex system of social stratification. A pantheon of gods combining human and animal elements, with a continued emphasis on felines and birds, was at the core of Moche ideology. The focus of their belief system was a complex ritual of human sacrifice known today as the Sacrifice Ceremony.

The discovery and excavation in the 1990s of the fourth-century tomb of a Moche ruler from Sipán, near the coastal town of Chiclayo, have revealed the great wealth and power of the ruling classes.[6] The findings also attest to the enormous advances made in the arts, particularly in metalwork and ceramics. Among the treasures found in this tomb are earflares decorated with animal and human motifs worked in gold and colorful stone mosaic, an enormous gold crown, bells and necklaces decorated with designs of supernatural beings, staffs of authority, weapons, and a necklace of beads in the form of oversized peanuts. Different metals were combined in a single object, and there was experimentation with new techniques, such as lost-wax casting, gilding, and silvering. Indeed, the variety and sophistication of metalworking techniques developed by the Moche smiths, in which the glittering surfaces and the colors of gold and silver were exploited, remain unparalleled in the Andes.

3. Moseley 1992, pp. 81ff.
4. Larco Hoyle 1941; Burger 1992.
5. Onuki 1997, pp. 79–114.
6. Alva and Donnan 1993.

Figure 7. Banner ornament, decapitator deity. Vicús region. Moche, from Loma Negra, Piura Valley, 2nd–3rd century. Silvered copper, height 10 in. (25.4 cm). The Metropolitan Museum of Art, Bequest of Jane Costello Goldberg, from the Collection of Arnold I. Goldberg, 1986 1987.394.69

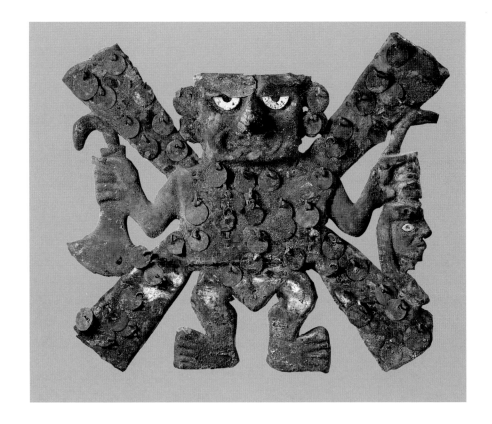

The themes seen in Moche metallurgy are frequently the same as those in ceramics—scenes of combat and the representation of deities. Nevertheless, perhaps because the metalsmiths worked independently, some designs in metal do not appear on ceramics, such as frontal figures of gods with outstretched arms and legs and prominent eyebrows and spider traits. These figures often hold severed heads and *tumis* (knives) and are known as decapitator gods (fig. 7).

One of the most impressive centers of Moche production was on the outskirts of Trujillo, at the site of the Pyramids of the Sun and Moon.[7] Unique structures, these elaborately decorated compounds, courts, and rooms were made of millions of adobe bricks. In ancient times, the Pyramid of the Moon was covered entirely with polychrome murals representing supernatural beings, warriors, and animals. At the base of the pyramid was a bustling urban center with a population of several thousand, which hummed with the activity of ceramic and metal workshops. Moche society collapsed about the eighth century, weakened externally by an increasingly unstable climate and hostile neighbors and internally by costly rituals and inefficiency.

It might be expected that Moche metallurgy was perfected progressively over time, but this is not the case. While the discoveries at Sipán are evidence of the advances associated with the development of Moche society, more recent research reveals that as the culture waned, about the seventh century, there was a noticeable decline in the use of metals and in metal technology. Metal appears in very limited quantities in funerary contexts. At San José de Moro, in the valley of Jequetepeque, important Moche tombs of this time have been found, particularly those of high-status women.[8] There are copper disks and sheets in these

7. Uceda et al. 1994, pp. 251–303.
8. Castillo Butters and Donnan 1994, pp. 93–146.

tombs, some worked in the form of headdresses and masks, but the techniques used to produce them indicate a marked impoverishment both in technology and in the availability of raw materials.

The decrease in metal production coincident with economic and political decline would not be difficult to explain, except for the fact that there was at the same time an increase in the production of ceramics. This involved the use of imported raw materials, as well as the exploration of new styles. The materials included clays and pigments, obsidian from the Central Highlands, spondylus shells from Ecuador, and feathers from the jungle. The weakened power of the elite in the final phase of Moche culture would certainly have resulted in a reduced production in the metal workshops and would have been a deterrent to acquiring raw materials. But because the opposite occurs in ceramic production, the explanation could not be solely economic. Rather, it would seem that metals ceased to have the prestige they had previously enjoyed. They are no longer the most elaborate contents of tombs; indeed, gilded copper earflares and ceremonial knives are the only objects closely associated with the dead. Nevertheless, while metalwork with decoration continued to be manufactured only on a reduced scale into the Lambayeque culture, there was an explosive increase in the volume of metal produced in the ninth century. The forms and techniques of these objects indicate a continuity between the traditions of the earlier Moche culture and that of the Lambayeque.

THE MIDDLE HORIZON AND THE LATE INTERMEDIATE PERIOD

Why Moche culture came to an end is a subject of intense debate. Various theories have been advanced. Some suggest that it was the result of ecological and climatic

Figure 8. Funerary mask. North Coast. Lambayeque, 10th–11th century. Gold, cinnabar, copper, height 11½ in. (29.2 cm). The Metropolitan Museum of Art, Gift and Bequest of Alice K. Bache, 1974, 1977 1974.271.35

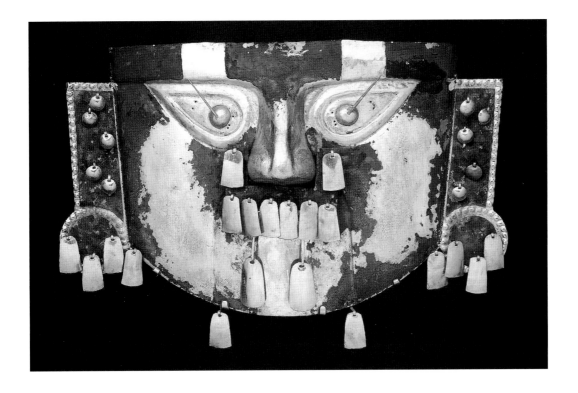

upheavals, such as the torrential rains of El Niño; others that it occurred in the wake of invasions from the south; and still others that it was concurrent with the weakening of the political authority of the elite resulting from the enormous cost of festivals and religious ceremonies, which served as the basis of the power structure. What is certain is that following the collapse of Moche culture, two states arose in the north: the Chimú, in the former Moche region south of the Chicama Valley, and the Lambayeque, in the Moche territory north of the Jequetepeque Valley. Both states continued traditions developed in Moche society, making advances in architecture, in textile and ceramic art, and in hydraulic engineering. In both cultures the most outstanding achievements in the arts were in metallurgy and metalwork. Lambayeque craftsmen excelled in working arsenic copper, and the Chimú produced remarkable works in silver. While the former imitated ceramic forms in their metalwork, the latter created distinctive human and animal figures. The gold masks of the Lambayeque painted with cinnabar are justly famous, combining several decorative techniques in a single object (fig. 8). Large quantities of metal objects—often found only as fragments—have been discovered in the tombs of the elite, accumulated as symbols of power.

Lambayeque society has been the subject of several archaeological investigations in recent years, particularly those of the complex of Batán Grande[9] and the site of Túcume,[10] near the town of Chiclayo. At Batán Grande individuals of the highest rank were buried in tombs rivaling in wealth those of Moche burials at Sipán. The Túcume complex, with impressive adobe pyramids embellished with polychrome and mud relief decorations, was an important center of Lambayeque culture until the Inka period.

The Chimú state dominated the North Coast before the Inka conquest in the late fifteenth century, controlled from the great capital of Chan Chan, the largest pre-Hispanic city built of adobe in Peru (fig. 9). In the vicinity of the great walled compounds known as *ciudadelas* (little cities), which appear to have served as the seats of power, there is evidence of housing for workers. The *ciudadelas* comprised living quarters, areas for state administration, a shrine complex, and a funerary platform where the ruler would eventually be buried. His successor would build his own *ciudadela*, and thus the capital would expand as each new ruler built his own royal compound, each one grander and more elaborate than that of his predecessor.

THE LATE HORIZON AND THE INKA EMPIRE

Only two generations before the arrival of the Spaniards in Peru, the Lambayeque and the Chimú were overrun by the Inka. The opulence and wealth that the Inka found had no parallel in their own culture. Chimú craftsmen were relocated to the Inka capital of Cuzco, in the South Highlands, to decorate tombs and palaces, endowing the city with the splendor and elegance of the north. The Inka empire grew rapidly, bringing about important changes in the political and economic systems of the many assimilated territories. At the beginning of the sixteenth

9. Shimada 1995.
10. Heyerdahl, Sandweiss, and Narváez 1995.

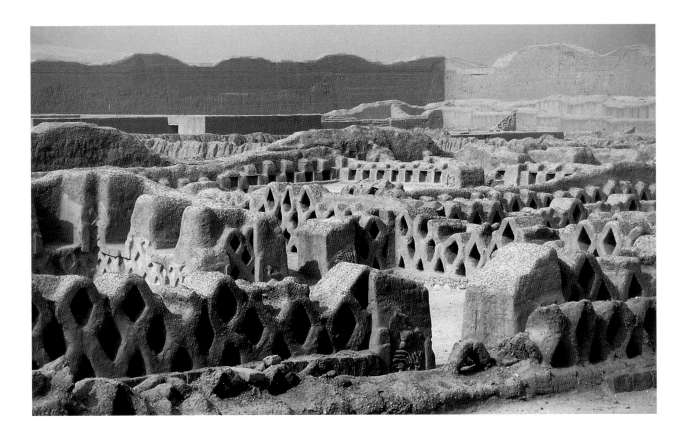

century its development was abruptly and tragically interrupted with the arrival of the Spanish conquerors, who destroyed many of the most important edifices and symbols of the culture, transforming Central Andean identity forever.

The written documents (which do not exist for earlier periods) that were compiled mostly by Spaniards and mestizos during and after the conquest have greatly facilitated the study of the Inka. And while they offer a Eurocentric view of the culture and are often biased and unreliable, the accounts of such writers as Cieza de León, Garcilaso de la Vega, Calancha, and Santa Cruz Pachacuti present the vast panorama of Inka society.[11]

The aesthetic that characterizes Inka culture is very different from that of earlier eras. Inka art is functional and austere. While the contributions of conquered societies were important in the formation of the imperial identity, the Inka sought to create a cultural homogeneity, imposing the use of one language (Quechua), the cult of the sun, and an architectural standard that lent a unified image to the lands of imperial authority. In metallurgy earlier traditions were followed, with tin bronze employed as the official alloy of the state.

The long evolution that extended from primitive forms of social organization to highly elaborate political systems culminated in the empire of Atahualpa, the last ruler of the Inka, ending the history of the most complex indigenous society of the South American continent. Fortunately, substantial material evidence of these cultures has survived, enabling us to reflect on the grandeur and nobility of the peoples who created them.

Figure 9. Tschudi royal compound at Chan Chan. Chimú, 15th century (photo: Heidi King)

11. Pease G. Y. 1995.

Silver in Precolumbian Peru

PALOMA CARCEDO DE MUFARECH

The silverwork of the ancient Peruvians is little described in the chronicles of the conquest and the colonial period. Information about mining, metallurgy, and crafted objects is scarce, and few authors comment on the work of silversmiths and the significance and use of silver among indigenous peoples. Consumed with thoughts of gold—the major expeditions of the conquest were undertaken in search of gold-rich lands—the early chroniclers generally mention silver and other metals, such as copper, bronze, lead, and tin, in connection with gold. But while gold was important in ancient American cultures, silver and especially copper are fundamental to understanding the development of Andean metallurgy.

Silver, which was plentiful in Peru, where it existed in both a native state (in metallic form) and in simple and complex ores, is one of the three metals on which ancient Peruvian metallurgy was based—copper and gold being the other two—and the sophisticated alloys that characterize Peruvian metalwork were formed of these three. Symbolic as well as functional and aesthetic considerations—form, color, and musicality—contributed to the final product, and the eternal dualities of sun and moon, day and night, heaven and earth, and right and left have found analogies in the Andean practice of joining gold and silver in the same object.[1]

SOURCES OF SILVER AND WORKING METHODS

Silver in its native state has a dendritic or fibrous appearance. It is a highly ductile, malleable metal, a good conductor of heat and electricity, and melts easily. White in color with a metallic sheen, it becomes a dull black when exposed to air. It is formed by the reduction of sulfides in oxidation zones in the earth. Surface deposits of silver, which existed in Peru in greater quantities than in any other region of South America,[2] were concentrated in a strip from eighty to somewhat more than a hundred miles in width, extending from Cajamarca in the north to Bolivia and Chile in the southeast. The width of this area increases toward the south, coinciding with the widening of the range of the Andes.[3] In these mountainous regions, silver was found in both a native state—which can be difficult to recognize due to its "non-nugget" and dendritic form—and in ores accessible only by the efforts and skills of the Precolumbian miners.[4] The early records most frequently name the deposit known as Porco, near Potosí in modern Bolivia. Porco was exploited by the Inka and mined by the colonial Spaniards after 1545.

Precolumbian Peruvian silver processing has been discussed widely since the days of the first reports. El Inca Garcilaso de la Vega, writing at the end of the

1. Alva 1994, pp. 72ff.
2. Peterson G. 1970, p. 50.
3. Oehm 1984, p. 14.
4. The remains of a prehistoric copper miner were discovered in northern Chile in 1899. For a description of the miner and his tools, see Bird 1979, pp. 105–32.

sixteenth and the early seventeenth century, had this to say about the silversmiths he had encountered several decades earlier:

> *Although they were so many and worked perpetually at their craft, they never made anvils of iron or any other metal. This must have been because they did not know how to found iron, though they had mines. They call iron quillay. They used hard stones of a color between green and yellow as anvils. They planed and smoothed them against one another; and esteemed them highly since they were very rare. They could not make hammers with wooden handles. They worked with instruments of copper and brass mixed together: they were shaped like dice with rounded corners. Some are as large as the hand can grip for heavy work; others are middle-sized, others small, and others elongated to hammer in a concave shape. They hold these hammers in the hand and strike with them like cobble-stones. They had no files or graving tools, nor bellows for founding. Their founding they did by blowing down copper pipes half an ell or less in length, according to the size of the work. The pipes were blocked at one end, but had a small hole through which the air came out compressed and with greater force. It might be necessary to use eight, ten, or twelve at once according to the furnace. They walked round the fire blowing, and still do today, for they do not like to change their habits. Nor had they tongs for getting the metal out of the fire. They used rods of wood or copper, and thrust the metal onto a lump of wet clay they had near to temper its heat. There they pushed it and turned it over and over until it was cool enough to pick up. Despite these handicaps they executed marvel-lous work, especially in hollowing things out, and other admirable things. . . . They also realized, despite their simplicity, that smoke from any metal was bad for health, and thus made their foun-dries, large or small, in the open air, in yards or spaces, and never under roof.*[5]

Contemporary accounts also describe smelting techniques and make note of three different types of furnace. One was a simple pit in the ground used to reduce silver or minerals rich in silver. Another was a small oven or reduction fur-nace called a *huayra* or *guaira*. These were portable and sometimes placed on hills, where the smelting process would benefit from gusts of wind. Reeds or other tubes with ceramic tips were used to provide the air needed to make the furnaces function properly, as the ancient Peruvians used no bellows in their metalworking. The third type of furnace was for refining metal, known as a *tocochimpu*, which was discussed primarily in the context of extracting silver and lead.

Sophisticated alloying techniques, in which the combining of metals produced a desired quality and color, were integral to Peruvian metallurgy. Copper was a fun-damental element in nearly all alloys, but it was the silver-hued or golden surfaces that were most valued, as they were emblematic of political and religious status. The colors of metal objects ranged from dark to light to reddish silver and from red to white to yellow gold, and the coloring of metallic surfaces, whether by deposition or diffusion, was one of the great skills of the Andean smiths.[6] Hardness, resis-tance, ductility, malleability, color, and shine were all achieved through alloying.

Central Andean silversmiths were adept at hammering techniques in the produc-tion of sheet metal, from which most of their work was constructed. In making the sheet they used tools of stone, such as small anvils, hammers, and dies; tools of wood, such as matrices, molds, and dies; tools of metal, such as chisels, perforators, awls, tracers, scribers, punches (fig. 10), and perhaps blowing tubes; and tools of ceramic, such as molds and crucibles (fig. 11). It is believed that the instruments were passed from father to son and in some cases, such as the carved matrices, that their designs served as patterns which endured for several generations. Indeed, ancient

5. Garcilaso de la Vega 1966, pp. 130–31.
6. Deposition: When the color of a metallic surface is changed by means of external agents, three techniques are used: fusion gilding, electrochemical replacement, and plating, or covering the surface with a thin sheet of metal. Diffusion: When the color of a metallic sur-face is changed by means of chemi-cal reactions in the alloy itself, the technique is known as depletion plating, surface enrichment, or mise-en-couleur.

Figure 10. Tools similar to those used
to make ceremonial rattle beakers like
those found at Huaca la Misa, Chan
Chan. Chimú. 14th–15th century.
Museo Nacional de Arqueología,
Antropología e Historia del Perú,
Lima (photo: Paloma Carcedo de
Mufarech)

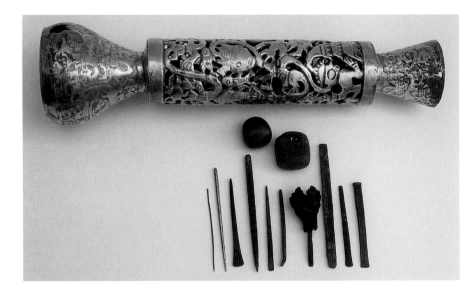

Figure 11. Fragments of ceramic
molds used to cast copper lime
spoons. North Coast. Chimú/Inka,
14th–15th century. Museo Nacional
de Arqueología, Antropología e
Historia del Perú, Lima (photo:
Paloma Carcedo de Mufarech)

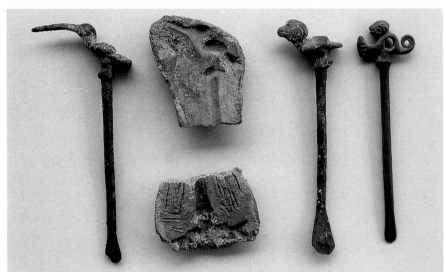

7. For a discussion of early tools in
the Museo Nacional de Arqueo-
logía, Antropología e Historia
del Perú, Lima, and in the Museo
Brüning Lambayeque, see Carcedo
de Mufarech 1998, particularly
pp. 247–62.

tools of wood and stone from the North Coast compare well with those in use
today. In addition to the decorative motifs, form, size, and weight are similar. Stone
matrices for cutting sheet and raising designs have also been found.[7]

The decorative applications employed in the basic hammering technique were
cutting, scribing, chasing, embossing (hammering the metal over a carved mold,
usually of wood; fig. 12; see also cat. no. 25); and repoussé (working the sheet free-
hand while it rests on a giving surface such as pitch or soft wood; fig. 13; see also
cat. no. 15). The finishing of surfaces was done by buffing and burnishing with
stone and bone polishers and abrasive sands. Surfaces could also be painted or
decorated with feathers.

Joining techniques required ingenuity and virtuosity. Individually worked pieces
of sheet were joined without complicated techniques, but multipiece objects were
feats of metallurgical complexity. Mechanical joins included tabs, staples and
nails, wires, and metallurgical joins, such as soldering, welding, and sweat or pres-
sure welding. Precise control of the direction and temperature of the flame in
order to prevent damage to the parts to be joined and to keep the solder, when

present, from running demanded great skill, as did mastery of the blowpipes, which manipulated the airflow.

THE WORKING OF SILVER NORTH AND SOUTH

The earliest and most prevalent examples of metalwork are of gold. These are tiny hammered platelets that come from the southern Andes and date to about 1500 B.C., evidence of the working of gold in a native state.[8] Objects of silver from this time are not known. The small plaques of silver discovered in a group of twenty-one (some of the objects are of gold) at the Cerro la Copa archaeological site of Kuntur Wasi are the earliest known examples of worked silver (see fig. 1). In the form of repoussé birds, they are made of a silver-rich alloy—in some instances composed of up to 70 percent silver and 30 percent gold—and date to between 800 and 500 B.C.[9]

During the Early Horizon (ca. 600–ca. 200 B.C.) an entire range of metallurgical and decorative techniques was used in northern Peru, although there is little evidence of works in silver beyond the Kuntur Wasi plaques. There are two other examples, but they are bimetallic, with silver as well as gold elements. One, said to be from Chavín de Huántar, in the Central Highlands, is an effigy spoon in which a gold figure holds a silver conch shell;[10] the other is a silver pin with a gold head from Chongoyape, in the coastal Lambayeque Valley.[11] The composition of the Chongoyape pin is 75 percent silver and 25 percent gold.[12] It was not until the subsequent Early Intermediate Period (ca. 200 B.C.–ca. A.D. 600) that important developments in the working of silver began to occur. In the north, the silver-working centers were in the area of Vicús, on the coast, and in Pashash, in the highlands.

Vicús, which dates from about 200 B.C. to about A.D. 500, has as its antecedents the Salinar and Virú (Gallinazo) cultures on the North Coast, and works from this time are extant in silver, gold, and copper. Vicús construction and decorative metalworking techniques comprise all those previously mentioned, as well as gilding and silver plating for surface embellishment on large disks, pectorals, and headdresses. Bimetallic works that were half silver and half gold were also produced. Nose ornaments were frequently made in this manner.[13] The Moche, who were the dominant culture on the North Coast from about A.D. 100 to 800, perfected the techniques and alloys developed by the Vicús and brought Andean metallurgy to its culmination. Nearly all Andean techniques for working metal, both metallurgically and mechanically, and all the means of decorating it were known to the Moche. Their astonishing manipulation of surface effects, which included electrochemical replacement plating and depletion plating, was one of the major technical accomplishments that they passed on to later northern peoples.[14]

The highland site of Pashash is centered in Cerro la Capilla, in the hills south of Cabana, in the Department of Ancash.[15] An important group of cast copper nails covered with thin gold leaf was found here, some of which have the appearance of silver. They date from about 300 B.C. to A.D. 500. Their manufacturing technique is largely unstudied.[16]

During the Middle Horizon (ca. 600–ca. 1000), when the great South Highland centers of Wari and Tiwanaku were very influential in much of central and southern Peru, metalworking declined. Few works in silver exist from this period.

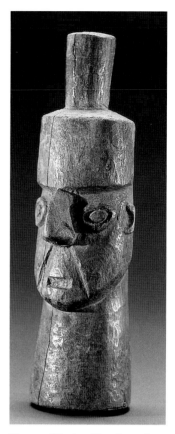

Figure 12. Wood mold used to make face beakers. South-Central Coast. Ica/Inka, 15th–early 16th century. American Museum of Natural History, New York

8. Grossman 1972.
9. Onuki 1995, p. 18.
10. Lothrop 1951, p. 233, pl. 77a. For a detailed technical description of this object, see Lechtman 1996a, pp. 59–66.
11. Lothrop 1941, p. 260, pl. xxc.
12. Lothrop 1951, p. 238.
13. Centeno and Schorsch 1996, pp. 165–85; Schorsch 1998, figs. 33, 34.
14. Lechtman, Erlij, and Barry 1982.
15. Grieder 1978, p. 119.
16. Ibid., pp. 238–47.

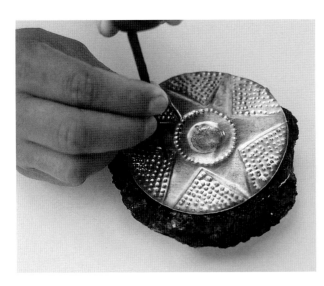

Figure 13. Creating a repoussé pattern with a Precolumbian tool (photo: Paloma Carcedo de Mufarech)

One exceptional object attributed to the Wari culture is a mask with cutout eyes and a fanged mouth, said to have been discovered at the ancient pilgrimage center of Pachacamac, on the Central Coast south of Lima.[17] Iconographically the mask belongs to an ancient Andean tradition whose roots are found in the Chavín culture, but its open eyes make it a new interpretation.

The pace of silverworking accelerated in the last two eras of Peruvian prehistory, the Late Intermediate Period (ca. 1000–ca. 1470) and the Late Horizon (ca. 1450–1534). This coincided on the North Coast with the gradual consolidation and centralization of political and religious power, and between about 850 and 1100 the Sicán culture of the La Leche Valley amassed enormous wealth in precious metals. These materials were then used to produce great numbers of objects of gold and silver, some very large, as in the graves of the Sicán rulers.[18] The Sicán metallurgical tradition was based on that of the Moche, their predecessors in the north.

Sicán culture combined the Moche metallurgical tradition with an iconography derived from the highland center of Wari. During its period of greatest authority a common image—one that dominates Sicán metalwork—is a figure that has been identified by some as the legendary leader Naymlap (see cat. nos. 8, 14).[19] Objects with this image were hammered, as casting was seldom used for pieces of silver or gold; more often it was employed for copper and copper-arsenic alloys. Sicán metalwork included masks, *tumis* (ceremonial knives), crowns, pectorals, ear ornaments, and vessels, composing a corpus rivaling that made by the subsequent Chimú culture on the North Coast. In the Chimú era (ca. 1100–ca. 1470) the capital city, Chan Chan, is believed to have had a concentration of major metal workshops. The number of works in silver that are extant suggests that silver, notably, was the preferred precious metal at that time.

Many Chimú works in silver have been unearthed in Chan Chan itself, unfortunately not by archaeologists. A significant find in the capital was made in the early 1920s in the burial platform of the Rivero compound, Huaca la Misa.[20] The find comprised a group of twenty unusual elongated cylindrical rattle vessels, sixteen of silver and four of gold, some with openwork midsections and with a cone-shaped vessel form at one end and a rounded cup at the other (see fig. 10). Another group was discovered in the 1960s (again by local people) in the Tschudi compound, which included three litter backrests, sixty cups of different shapes, and twenty large disks.[21] A third important find was reported farther north, in the Chicama Valley, at Hacienda Mocollope (see cat. nos. 7, 11–18).[22] The quantity and quality of these objects are unprecedented in Chimú metalwork. Sharing an iconography found in ceramics, the silver vessels are single- and double-chambered pieces in the form of animals, birds, and human figures, some of which have repoussé designs resembling representations on temples (see cat. no. 13). These were made from individual objects of silver-copper sheet that were soldered together.[23] Chimú casting, which was technically very

17. Emmerich 1965, p. 23, fig. 26.
18. On Sicán graves, see Carcedo de Mufarech and Shimada 1985; on Sicán culture, see Shimada 1995.
19. Shimada 1995, pp. 8–11.
20. Ríos and Retamozo 1982.
21. Carcedo de Mufarech 1989, pp. 249–70.
22. Lapiner 1976, p. 447, n. 600.
23. Use of soldering was revealed in technical examination of vessels from this find in the Sherman Fairchild Center for Objects Conservation at The Metropolitan Museum of Art.

sophisticated, was reserved for other types of objects, such as tall pins and lime spoons (see fig. 11).[24]

Events in southern Peru appear to have had a somewhat different trajectory from those in the north. Gold, again the first metal to be worked there, is not present until about 700 to 100 B.C., when hammered and repoussé gold objects were produced by peoples of the Paracas culture on the coast. No example of worked silver or copper from this period has yet been identified, although a few gold objects have enough silver and/or copper in their composition to indicate the presence of alloys, albeit naturally occurring ones.[25] In the subsequent Nazca culture as well (ca. 100 B.C.–ca. A.D. 600), no silver or copper objects have been identified and very little admixture of these metals appears to be present in the worked gold. Evidence of soldering, however, is found in Nazca goldwork; the earliest appearance of this technique is on the South Coast.[26]

It would be two to three hundred years (after about A.D. 900) before intentionally alloyed metals were made in the southern coastal region. Evidence of this important change from naturally occurring to intentionally made alloys is at present unknown, as it seems to have taken place during the centuries for which there are no archaeological records. By the time man-made alloys particularly rich in silver were in use in this region, a local imagery that incorporated bird motifs had been established and surface enrichment of silver-hued objects was in practice. Tweezers, bracelets, plaques, disks, and an occasional small mask were embellished with such surfaces. Fashioned from hammered sheet, these works were decidedly silver in color, the result of a manipulation of the metal mixture.

On the South Coast during the Late Chincha and Ica phases (ca. 1100–ca. 1450)—contemporary with the northern Chimú culture—silver objects such as disks, masks, bowls, and effigy beakers were produced in abundance. The effigy beakers resembled those of the northern Chimú and were made in the same manner—by raising silver-copper sheet metal over a wooden form and hammering it into shape—which most likely indicates an influence from that region (see fig. 12 and cat. no. 25). Intermittent annealing was required to restore malleability, lost during the hammering process. Most alloys used were of silver and copper, the silver content sometimes higher than 80 percent.[27] Objects made of high-copper alloy sheet were often treated to give the metal a silver-looking surface, as both the hammering and annealing processes as well as the chemical treatments served to deplete copper from the surface, leaving a thin layer of pure silver.

The last period of Precolumbian Peruvian history, the Late Horizon (ca. 1450–1534), corresponds to the era of Inka domination, beginning in 1460 and ending with the arrival of the Spaniards in 1532. The Spanish obsession with precious metals led to the melting down of all gold and silver objects that the conquerors came across and, as a result, few Inka works in precious metals survive. None of the gold and silver objects found in temples and gardens are extant, and only small objects remain to exemplify Inka types. Diminutive male and female figures, llamas and alpacas, and beakers are the primary remnants from that time, when a major and long-enduring metallurgical tradition flourished, one in which silver was of fundamental importance.

24. Powdered lime, often made of calcined seashells, was taken in the Andean Highlands in conjunction with the ritual use of coca. The spoons were used to extract the lime from the small containers in which it was kept.
25. Root 1949, p. 12.
26. Ibid., p. 14.
27. Ibid., pp. 17–30.

Catalogue

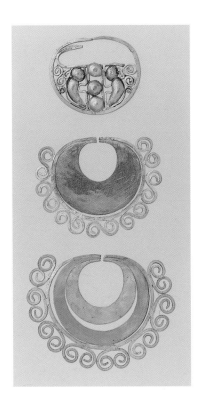

1. Three nose ornaments

North Coast. Salinar(?), 1st century B.C—1st century A.D.
Gold, silver, height ⅞ in. (2.2 cm); 1⅛ in. (2.9 cm); 1⅜ in. (3.5 cm)
The Metropolitan Museum of Art, Rogers Fund, 2000 2000.6 (top)
Anonymous loan (middle and bottom)

Nose ornaments, worn mostly by high-status males, are among the earliest forms of personal jewelry in ancient Peru. They remained in fashion for over a thousand years, from about 500 B.C. to about A.D. 800. Those with delicate soldered filigree display elaborate scrollwork as well as braided and spiral patterns, giving the ornaments a lacelike appearance. In many examples there are small hemispheres or tiny animal figures, here displayed on the top ornament, which are perhaps monkeys with long tails. Often hammered sheet silver is used with gold, producing a pleasing color contrast. The differentiation between the silver and gold tones is frequently subtle. It was intentionally created by manipulating the amounts of silver and gold in the alloy. The combination of silver and gold on one ornament can also be seen in Moche metalwork (ca. 200–ca. 600), where it is thought to have had symbolic significance.

Because these nose rings were not excavated by archaeologists, their cultural attribution and dating are only speculative. They have been ascribed to both the Salinar and the Virú (Gallinazo), two regional cultures that preceded the rise of Moche civilization on the North Coast. They also show stylistic affinities to nose ornaments from Ecuador, particularly those of the Tolita style, which are found near the border with Colombia.

2. Nose ornament with shrimp

Vicús region. Moche, from Loma Negra, Piura Valley, 2nd–3rd century
Silver, gold, greenstone, 4¾ x 7¼ in. (12.1 x 18.4 cm)
The Metropolitan Museum of Art, The Michael C. Rockefeller Memorial
Collection, Bequest of Nelson A. Rockefeller, 1979 1979.206.1236

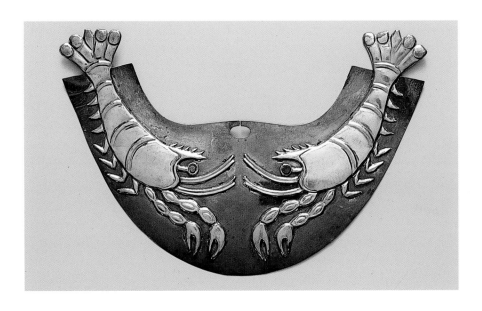

The Moche inhabited the arid desert coast of northern Peru and depended on products from the sea for food and for inland trade. Sea creatures of all kinds played an important role in their mythology as well and are frequent themes in their art. On this nose ornament, which covered the wearer's mouth when worn, two realistically rendered shrimp are worked in sheet gold tabbed through slits to the silver crescent. Nose ornaments were an essential part of Moche royal regalia. Recently excavated tombs of Moche dignitaries laid to rest with all their finery over sixteen hundred years ago at Sipán have yielded several types of nose ornaments associated with the same individual. Those shaped like crescents are of gold; others combine silver with gold.[1] The shape and combination of metals may have signified the function and/or rank of the individual.

1. Alva and Donnan 1993, pp. 77, 201–4.

3. Pair of earflares with condors

Vicús region. Moche, from Loma Negra, Piura Valley, 2nd–3rd century
Gilt copper, silver, gold, shell inlay, diam. 3 in. (7.6 cm), length with shaft 3½ in. (8.9 cm)
The Metropolitan Museum of Art, The Michael C. Rockefeller Memorial Collection, Bequest of Nelson A. Rockefeller, 1979
1979.206.1245, 1246

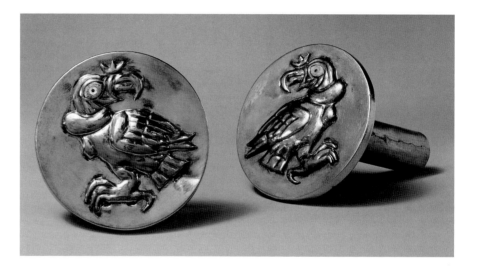

Moche metalsmiths were among the most inventive and skilled in ancient Peru, developing sophisti- cated techniques for joining the three basic metals that they worked: gold, copper, and silver.[1] Scholars of Moche art have sug- gested that, in addition to its aesthetic appeal, the combination of gold and silver on precious jewelry may have had symbolic meaning, perhaps expressing ideas of duality and complemen- tarity.[2] Gold and silver were used both as foreground and background. On these technically complex ear ornaments the front plates are made of sheet gold, to which repoussé silver birds are tabbed. The back plates and shafts, of gilded copper, are also joined in this manner. Ear and nose ornaments were worn in holes in the earlobes and nasal septum, respectively, as shown in figure 14. This ornament, itself worn suspended from the nose, is in the form of a human face wearing earflares and a nose ornament of the same shape as catalogue no. 2. The shafts of ear ornaments were often of substantial size, as in catalogue nos. 4 and 16, requiring the earlobes to be quite distended to accommodate them.

1. Schorsch 1998, pp. 109–36.
2. Excavations at Sipán have yielded gold objects placed con- sistently on the right side of the individual and silver on the left. Such placement corresponds to early colonial accounts stating that the native people associated gold with the right side and mas- culinity and silver with the left side and femininity (Alva and Donnan 1993, pp. 221–23).

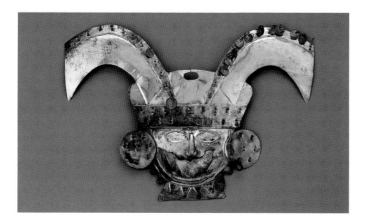

Figure 14. Nose ornament. Vicús region. Moche, from Loma Negra, Piura Valley, 2nd–3rd century. Hammered gold, partially silvered, silver, width 7½ in. (18.9 cm). The Metropolitan Museum of Art, The Michael C. Rockefeller Memorial Collection, Bequest of Nelson A. Rockefeller, 1979 1979.206.1223

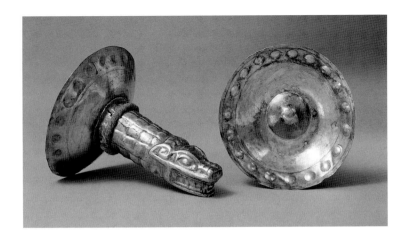

4. Pair of earflares
Coastal Wari / Tiwanaku, 7th–10th century
Silver, cotton, diam. 3⅜ in. (8.6 cm),
length with shaft 3¾ in. (9.5 cm)
The Metropolitan Museum of Art, Bequest
of Jane Costello Goldberg, from the
Collection of Arnold I. Goldberg, 1986
1987.394.580, 581

During the time the city-states of Wari and Tiwanaku were in power in the Central Andes personal ornaments of precious metal—indicators of rank and status in the earlier Moche civilization (ca. 200–ca. 600) and later in the Lambayeque, Chimú, and Inka cultures (ca. 900–1534)—became less important. Nose ornaments were no longer worn, and only a few examples of ear ornaments in silver and gold are known. The hollow shafts on this pair of earflares contain clappers and are worked as serpents with scaly bodies and big, toothy mouths. Serpents are a frequent theme in the art of coastal cultures, and the chevron band that separates the head from the body is a typical Wari design often found on ceramics and textiles. The ornaments may come from the Central Coast, an area controlled by the Wari after the eighth century. They still have the original tight-fitting stops made of cotton thread, which kept the earflares in place when worn.

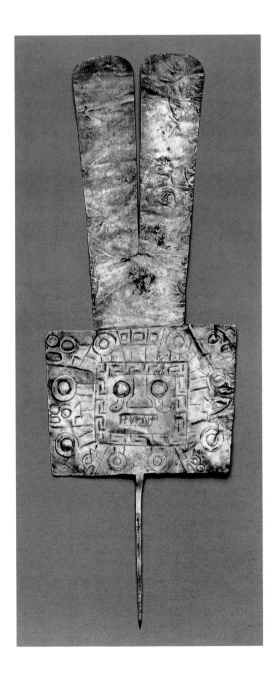

5. Plume with chased face
South Highlands. Wari / Tiwanaku, 7th–10th century
Silvered copper, height 15¾ in. (40 cm)
The Art Museum, Princeton University

This ornament is part of a large collection of metal objects reportedly discovered in the late 1970s by local people in several tombs in the vicinity of the village of Pomacanchi, southeast of Cuzco.[1] The find consisted of well over one hundred silvered copper objects, among them plumes, plain arm and ankle ornaments, and bells shaped like clamshells. On the front of the rectangular part of the ornament, which is topped by two plumes, is a stylized square frontal face with a fanged mouth and tear bands under the eyes. Profile puma heads emanate raylike from the frame of the face. Such ornaments may have been attached to headdresses or crowns worn by individuals of high rank.

1. Chávez 1984–85.

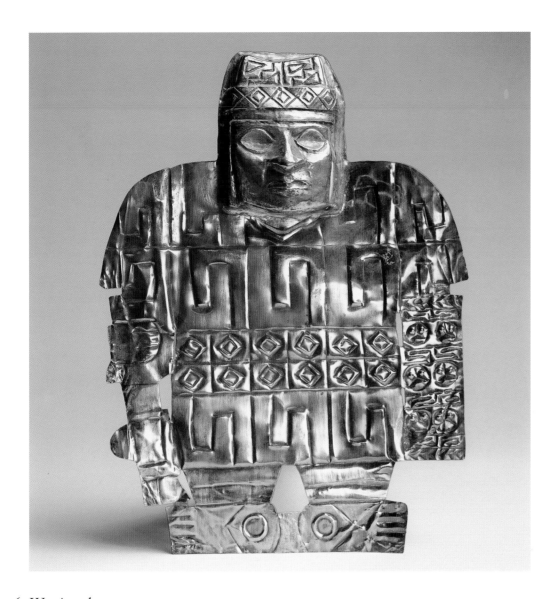

6. Warrior plaque

Wari, 7th—10th century
Silver, 10 ¼ x 7 ⅜ in. (26 x 18.7 cm)
The Glassell Collection

Metal finds from the Wari and Tiwanaku cultures, which rose to power in the South Highlands after A.D. 600, are rare. It would appear that there was less interest in precious metals during this time, and other materials, such as textiles and ceramics, were more frequently used for the manufacture of prestige items for the elite. This plaque is in the form of a broad-shouldered warrior holding a spear-thrower in his right hand and an oblong shield with stylized repoussé faces in his left. His flat body is covered with a long tunic with an interlocked hook design and a double belt with a diamond pattern. The squarish face projects three-dimensionally. The eyes were once probably inlaid, perhaps with shell and semiprecious stone, which would have given the face a lifelike expression. The head is covered with a four-cornered hat with a diamond and stepped-triangle pattern. How this handsome object functioned in ancient times is not known; it may have been attached to some form of backing. While the diamonds and stepped triangles are typical motifs on Wari textiles, the hook motif is not known on real garments. An identical object in sheet gold is illustrated in a recent publication.[1] Perhaps these two objects were a pair.

1. Lavalle 1992, fig. 202.

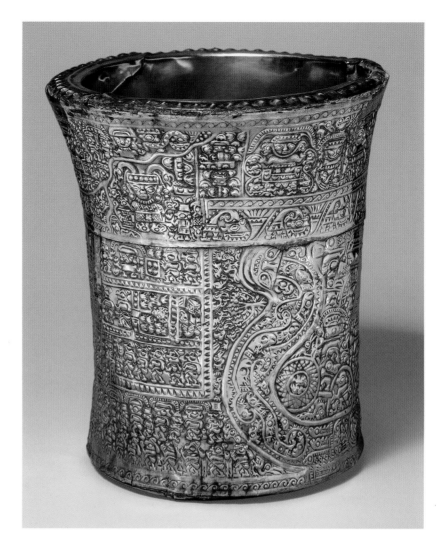

7. Double-walled beaker with repoussé decoration

North Coast. Lambayeque (Sicán)/Chimú, 14th–15th century
Silver, height 6 in. (15.2 cm), diam. 5½ in. (14 cm)
Denver Art Museum

1. The vessel was probably made at a time when the Chimú controlled Lambayeque territory. For a detailed description of the Lambayeque culture, see Shimada 1985, pp. 76–133; for Lambayeque facial features in particular, see p. 99.

Tall cylindrical beakers in precious metal, particularly in gold, have been recovered from elite burials in substantial numbers in the La Leche Valley. Among typical motifs decorating such beakers are frontal human and deity faces, but dense overall decoration and narrative scenes, as on this example, are unusual in Lambayeque art. Overall decoration is more frequently seen on later Chimú works (see cat. nos. 14, 15), but is usually in the form of repeat motifs. The almond-shaped eyes, one of the distinguishing features of the Lambayeque style, on what appear to be the protagonists in the scenes on this example would support its attribution to the Lambayeque culture.[1]

The beaker was part of the large silver finds on the North Coast in the mid-1960s (see cat. no. 11, n. 1). Arguably the most elaborate and iconographically rich work in precious metal to survive from the Lambayeque, the beaker is made of three

separate sheets of silver joined by soldering and crimping. Its entire surface, including the bottom, is covered with intricate narratives executed in exceptionally fine repoussé. The upper third is double walled, with a wide rim with bosses and a recessed spout on one side. The delicate relief decoration was achieved by hammering or pressing the metal into a bed of resilient material, such as pitch, and the surface was worked from the front and back with different types of chasing tools—tracers, punches, and scribers.

The narrative scenes involve numerous characters, some human, others part human—part animal. Many wear patterned garments and elaborate headdresses. Some stand on reed boats, while others are shown in enclosures. There are also large numbers of small figures in profile, who are shown carrying loads, and a variety of animals, birds, fish, serpents, plants, and trees. Most prominent is a large snakelike creature with animal figures on its long body. Emerging from the middle as well as from the tail end are two large splayed frontal figures.

The extraordinary importance this vessel must have had for the Lambayeque people is evident from the fact that its underside is also covered with dense iconography in repoussé. At the bottom is a full-sized human figure with its head bent back and wearing a crescent headdress. The figure reaches into a circular enclosure filled with animal heads, a human figure with serpent headdress, and a fantastic bug-eyed creature with massive paws. To the left of the enclosure a passage opens into a walled-in rectangular space filled with corn plants and anthropomorphic animals.

The absence of indigenous written texts makes the interpretation of the motifs problematic, and the Spaniards had little interest in recording the histories and mythologies of the local peoples. It is reasonable to assume, however, that because of the presence of many fantastic creatures and composite beings, cosmological scenes and mythic episodes are depicted. The images perhaps refer to the creation of the universe or to the origin of the Lambayeque people. It is also possible that they depict partly legendary, partly historical events and characters mentioned in accounts compiled by the Spaniards after the conquest (see also cat. no. 14).

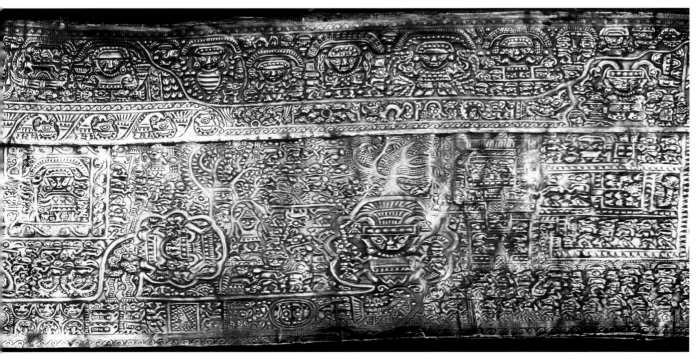

Photo: Justin Kerr

35

8. Rattle beaker with face

North Coast. Lambayeque (Sicán), 10th–11th century
Silver, gold, height 5 ⅜ in. (13.7 cm), diam. 3 ⅜ in. (8.6 cm)
American Museum of Natural History, New York

1. For a description of some of the richest tombs, see Carcedo de Mufarech and Shimada 1985, p. 62. The Lambayeque (Sicán) culture lasted from about 700 to 1375, when it was conquered by the Chimú people. Archaeologists distinguish between three phases: Early Sicán, ca. 700–ca. 900; Middle Sicán, ca. 900–ca. 1100; and Late Sicán, ca. 1100–ca. 1375 (Shimada 1995, p. 2). The spectacular precious metal finds date from the Middle Sicán.

The burials of Lambayeque royalty in the La Leche Valley, on the North Coast, contained the most impressive hoards of precious metal objects ever found in the Americas.[1] Prominent among Lambayeque tomb furnishings are flared, tumbler-shaped vessels mostly made of gold; those of silver now in collections are rare, perhaps because fewer were made, or perhaps because they did not survive the many centuries of burial as well as did those of gold. The beakers probably served in ritual contexts at royal courts and in temples during the lives of important individuals before being buried with them when they died. The imagery on the beakers, whether gold or silver, is the same. One group is decorated with faces that are upside down when the beaker itself is upright. Invariably the faces on such beakers have fanged mouths, as seen here. It has been suggested that the face may depict the supreme Lambayeque deity or perhaps Naymlap, the legendary founder of the Lambayeque dynasty (see also cat. no. 14). This beaker, which has a gold band around the rim, is part of a small group that has double bottoms with pellets that rattle when the beakers are moved. The silver on the midsection has converted to silver chloride during many centuries of exposure to salts and minerals in the ground and cannot be restored to its original sheen.

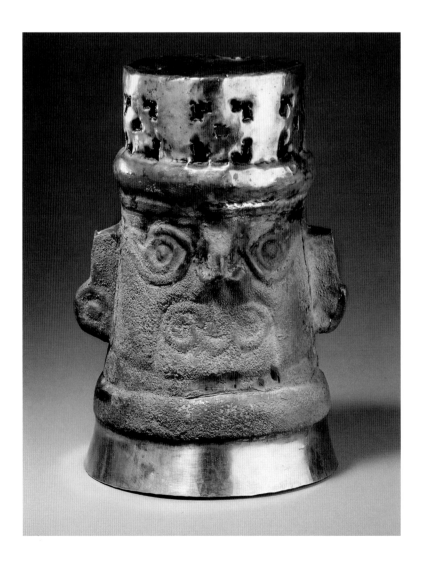

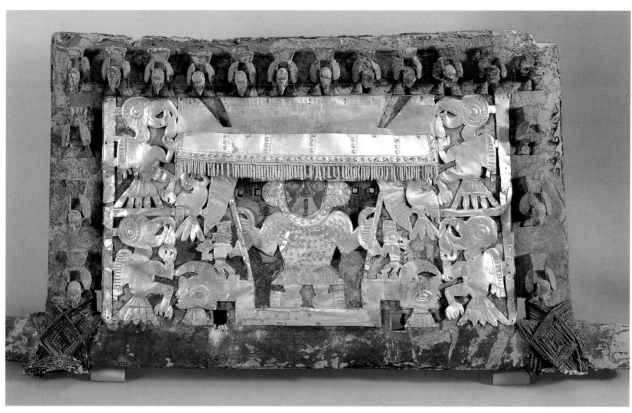

9. Litter backrest

North-Central Coast. Chimú, reportedly found in the Huarmey Valley, 14th–15th century
Wood, spondylus shell, feathers, silver, cinnabar, 20⅛ x 41⅜ in. (51.1 x 105.1 cm)
Peabody Museum of Archaeology and Ethnology, Harvard University, Cambridge, Massachusetts

In many societies that did not have draft animals and wheeled vehicles, important individuals were carried in litters (see cat. no. 21). Made of wood in ancient Peru, the backrests of such litters were often embellished with carvings, colorful featherwork, and precious metal appliqués. Only a few litter backrests are known to have survived from Precolumbian Peru.[1] This example reportedly came from the southernmost part of the Chimú empire, while all others were allegedly found near the royal residences of the Chimú kings at Chan Chan, the capital city, on the outskirts of the modern town of Trujillo, on the Pacific North Coast. Carved from a single slab of wood, it has eighteen small bird figures, probably depicting macaws, around the border. The birds and the background were once covered with tiny feathers of different hues, including those of the blue and yellow macaw, a tropical bird whose natural habitat is the eastern slopes of the Andes. Sadly, few feathers remain. In the center is a cutout sheet-silver panel showing a tall human figure under an awning fringed with strings of small spondylus (thorny oyster) beads. The figure, who probably depicts a ruler or high-ranking individual in Chimú society, is flanked by two smaller attendants. All three stand on a platform in the shape of a double-headed serpent and are surrounded by anthropomorphized birds. The ruler wears a tunic with a dotted pattern, a collar, and earspools. His face is painted with cinnabar, a mercury-bearing ore, and he holds staffs in each hand. At either side at the bottom are cord lashings, which originally held this upright piece to the crossbeams that formed the supports for the base of the litter. It is possible that the block of wood for this backrest was brought to the North Coast from the eastern slopes of the Andes, as trees large enough to produce planks of this size are very rare on Peru's desert coast.

1. The Museo de Oro del Perú, Lima, owns two (Carcedo de Mufarech 1989, pp. 249–70); there is one in the Museo Amano, Lima (*Museums of the Andes* 1981, p. 117); one in the Enrico Poli Collection, Lima (Bonavia 1994, p. 228); one in the Museo Nacional de Antropología y Arqueología, Lima (unpublished); and one in The Cleveland Museum of Art (1978, p. 403).

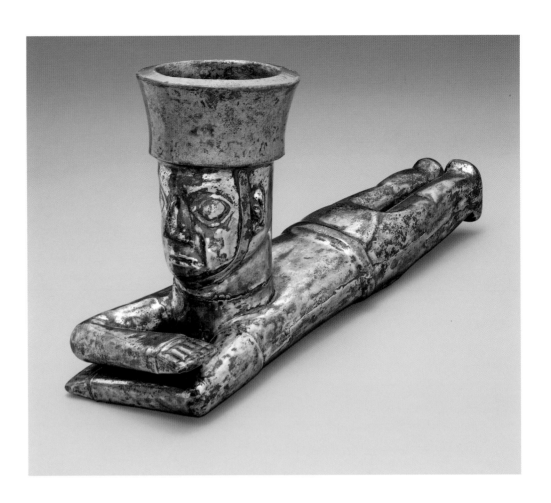

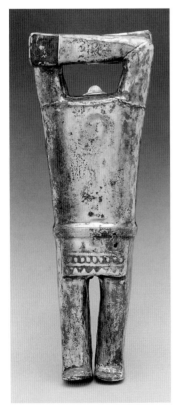

10. Vessel in the form of an outstretched figure

North Coast. Chimú, 14th–15th century
Silver, gold alloy, 4 ½ x 8 in. (11.4 x 20.3 cm)
Eugene Chesrow

This vessel is in the shape of an outstretched male figure. Most unusual is the figure's posture: with legs fully extended, he is shown lying on his stomach. The arms are bent at the elbows and crossed one over the other. The head, held upright, is crowned by a wide cap of gold alloy held in place with a chin strap. On the underside is a loincloth with a dotted pattern. Vessels in the form of human figures in a variety of poses have been common on the North Coast since the second millennium B.C., but those in the shape of an outstretched figure are rare.[1] The meaning of this posture is not known. Small figures in this position occur on a number of ceramic bottles from the Lambayeque culture (ca. 900–ca. 1300), where they are shown flanking or facing a central human image.[2] Judging from the depiction of the eyes and the shape of the cap worn on this example, it may be attributed to the Chimú culture. The vessel is made of eleven separately shaped pieces of sheet silver tabbed together or joined by solder.

1. A few ceramic examples are known from the Vicús culture, which flourished on the far North Coast more than one thousand years before the Chimú (Makowski et al. 1994, figs. 328–30).
2. Several examples were excavated at Huaca Loro, Batán Grande (Shimada 1997, nos. 99, 101).

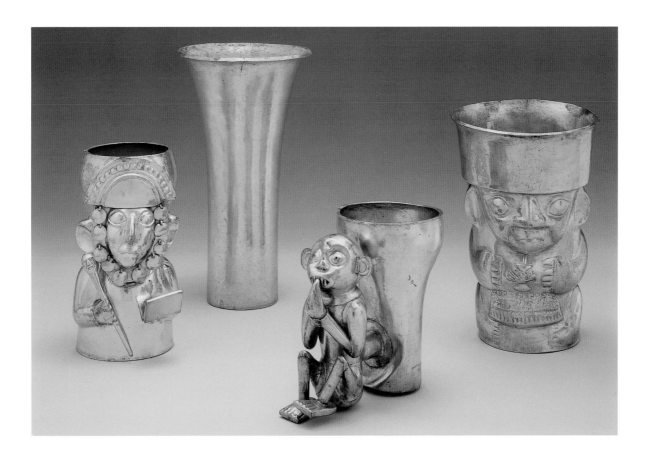

11. Group of vessels

North Coast. Chimú, 14th–15th century
Silver, max. height 9¼ in. (23.5 cm)
The Metropolitan Museum of Art, The Michael C. Rockefeller Memorial Collection,
Gift of Nelson A. Rockefeller, 1969 1978.412.162, 167, 171, 185

The Chimú, who dominated Peru's North Coast between the twelfth and the fifteenth century, were such accomplished metalworkers that the Inka, after conquering their territory in the 1470s, relocated the best of them to their capital city of Cuzco in the South Highlands, to work for the royal court. Much of the gold and silver worked by the Chimú was shaped into containers of various kinds rather than into objects of personal adornment, as was the case during Moche dominance of this region many centuries earlier. The vessels illustrated here, as well as catalogue nos. 7, 12–18, were part of the large finds of silver objects made by local people on the North Coast in the mid-1960s.[1] This group shows the diversity of shapes into which Chimú metal artists fashioned sheet silver, ranging from plain yet elegant and well-proportioned flared beakers to naturalistically rendered animal and human forms. In some instances the effigy itself is the container, as in the case of the warrior at the left with a shield and removable club, while in others the figure is joined to the vessel by a bridge, as represented by the monkey holding a fruit to its mouth. The male figure at the right is a hunchback; he wears a cap and decorated loincloth with tassels and holds with both hands a beaker in the form of a bird.

1. The location as well as the number of silver finds made at that time is unclear. The one published account (Lapiner 1976, p. 447, n. 600) states that according to oral reports, about thirty-five silver effigy vessels, twenty-five (?) silver disks with repoussé decoration, and from twenty-five to fifty plain disks, a litter backrest now in the collection of the Museo de Oro del Perú, Lima, and a group of forty-five to fifty silver cups and vessels were among the furnishings removed from one or several burials on the grounds of the Hacienda Mocollope, in the Chicama Valley. The Junius Bird archive in the Department of Anthropology at the American Museum of Natural History, New York, contains a photographic record of many objects that were part of the finds and a letter from Alan Sawyer suggesting that the silver objects may have come from the Tschudi royal compound at Chan Chan.

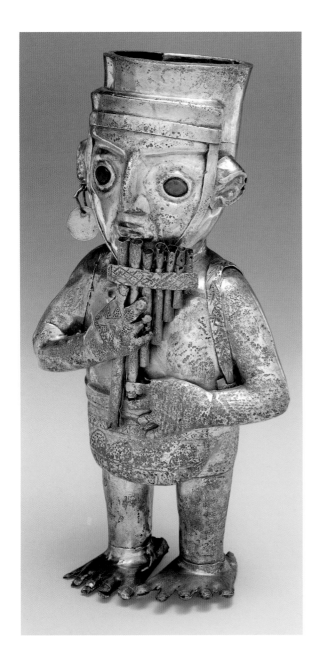

now missing). The finger- and toenails are indicated by incision. The motifs on the back of the hands probably represent body paint or tattooing.

Music was essential to religious and political ceremonies in Andean cultures. It was also performed, primarily on wind and percussion instruments, for entertainment and to accompany daily tasks, such as herding and working in the fields. Stringed instruments currently in use in the Andes, such as the *charanga*, were introduced by the Europeans. Many depictions of music-making in various media survive, and finds of actual instruments—panpipes, drums, horns, and rattles— are frequent in burials.

Elaborate vessels such as this one, which often have a short section on the rim cut out for pouring, were probably used in court or ceremonial drinking rituals before they were placed in the tomb of an important individual. The vessel is made of several separate preformed sections joined by welding and soldering.

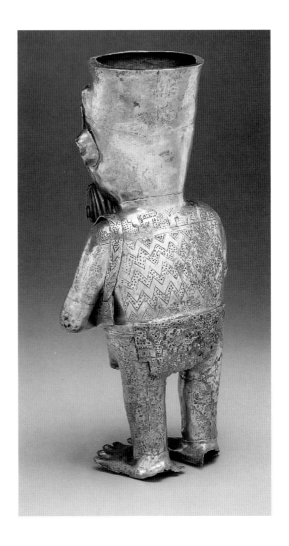

12. Panpiper vessel

North Coast. Chimú, 14th–15th century
Silver, malachite inlay, height 8¼ in. (20.9 cm)
The Metropolitan Museum of Art, The Michael C. Rockefeller Memorial
Collection, Gift of Nelson A. Rockefeller, 1969 1978.412.219

Quintessentially Andean, this appealing vessel is in the shape of a man playing a panpipe. He is dressed in a tunic and loincloth and carries a shoulder bag. The chased and stippled scroll designs, step-fret motifs, and zigzag patterns on his clothing are typically found on textiles that survive from this period. He also wears a cap and earrings (one

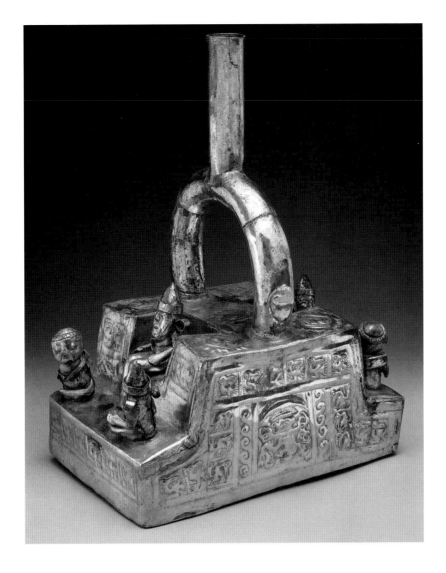

13. Throne vessel with figures

North Coast. Chimú, 14th–15th century
Silver, 9¼ x 6½ x 4⅛ in. (23.5 x 16.5 x 10.6 cm)
The Metropolitan Museum of Art, The Michael C. Rockefeller Memorial
Collection, Gift of Nelson A. Rockefeller, 1969 1978.412.170

This vessel is in the shape of an architectural structure. The upper part of the stepped platform forming the chamber serves as a seat or throne for a man wearing a conical cap. He may be a ruler or a chieftain receiving the two lower-ranking individuals seated at his feet. The same scene is repeated on the opposite side. The platform is decorated on all sides with shallow repoussé motifs reminiscent of the adobe reliefs that covered the walls of special structures in Chan Chan, the Chimú capital (fig. 15). The vessel has a spout in the form of a stirrup, a shape that was common on ceremonial vessels on the North Coast from the second millennium B.C.

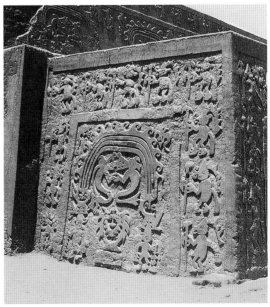

Figure 15. Huaca el Dragón structure at Chan Chan. Chimú, 15th century (photo: Heidi King)

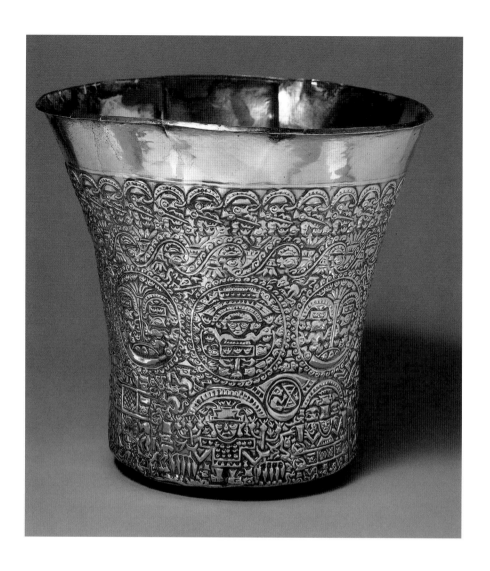

14. Beaker with repoussé decoration

North Coast. Chimú, 14th–15th century
Silver, height 7 in. (17.8 cm), diam. 7½ in. (19.1 cm)
Denver Art Museum

1. Cummins 1988, p. 250, cited in Pillsbury 1997, p. 189.

Tumbler-shaped vessels with flared rims are known in Peru as *keros*. The shape originated with the Wari and Tiwanaku cultures (ca. 600–ca. 1000) and remained popular into the colonial period. Used for the consumption of *chicha* (fermented beverages), particularly maize beer, *keros* were made of different materials, including wood, clay, silver, and gold, the material probably reflecting the social status of the owner.[1] Those of precious metal are called *akillas.* This beaker is made of a single sheet of silver; one section at the rim is shaped for pouring.

The design on this rare beaker is arranged in four registers. The first shows repeats of crested club-bearing creatures in profile; the second has a continuous wave motif.

The third register shows eight medallions in which frontal human figures alternate with anthropomorphic beings in profile placed on either side of a vertical element. Birds of various kinds, spondylus shells, fish, and fantastic beings proliferate in and around the medallions. From one medallion descends a band or "stream" filled with water creatures. The bottom register displays a row of eight frontal figures, each wearing a different detailed garb; one of them is carried in a litter (see also cat. nos. 9, 21). The spaces between them are filled with a variety of land creatures, birds, and vegetal forms. In one small circular frame, on the bottom left, a weaver sits in front of an X-shaped loom. The bottom of the beaker features a large scorpion in the center of a medallion. It has a human head crowned with a huge fanned headdress and is surrounded by land animals. The encircling band is filled with frontal catlike faces and animals with long tails in profile. The relief side of the design is on the inside.

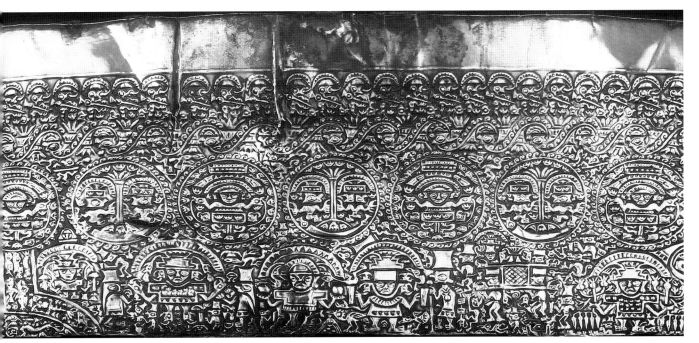

The figures on the vessel may refer to Chimú mythology, or they may depict historical or semi-legendary characters mentioned in sixteenth-century Spanish documents. Although only a few surviving early accounts deal with indigenous cosmology and history, one document, dated 1586, is of particular relevance for the North-Coast cultures.[2] The document relates the history—perhaps factual, perhaps legendary, or a combination of both—of the dynasties beginning in the era of a king named Naymlap, who ruled in the Lambayeque Valley "in times so very ancient that they do not know to express them."[3] The account lists twelve rulers during the dynasty of Naymlap and nine during the subsequent Chimú dynasty.[4] It is possible that some of the figures on this vessel, especially the eight frontal figures around the base, correspond to individuals mentioned in this text.

2. Cabello de Balboa 1586, cited in Donnan 1990, pp. 243–45.
3. Means 1931, p. 51.
4. Ibid., p. 55.

Photo: Justin Kerr

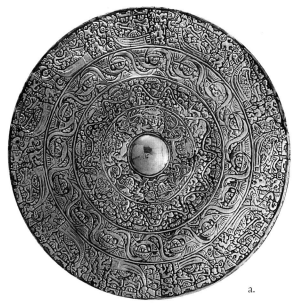

a.

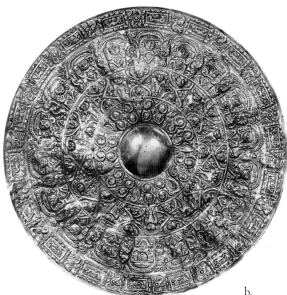

b.

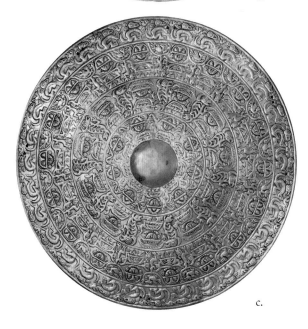

c.

15. Four disks

North Coast. Chimú, 14th–15th century
Silver, diam. 13½ in. (34.3 cm)
a. *Lowe Art Museum, University of Miami, Coral Gables*
b. *Dumbarton Oaks, Washington, D.C.*
c. *The Metropolitan Museum of Art, Gift and Bequest of Alice K. Bache, 1966, 1977 66.196.44*
d. *The Metropolitan Museum of Art, The Michael C. Rockefeller Memorial Collection, Gift of Nelson A. Rockefeller, 1969 1978.412.144*

These impressive disks are part of the large silver finds recovered from elite burials on the North Coast (see also cat. nos. 7, 11–18).[1] An analysis of the decoration on the eleven known examples reveals that four different design types were used. One example of each type is illustrated here.

The relief decoration was achieved by working the metal with chasing tools and punches from the back while the sheet rested on a resilient material, such as pitch or soft wood. The raised relief elements were then sharpened on the front with tracers.[2] The layout of the design is the same on all four disks: four concentric bands encircle an undecorated central boss, and although the motifs in each band differ from those in the others, they are repeated within the band. The use of repeat designs is characteristic of Chimú art. The iconography on two of the four disks relates to the sea and to marine life (15a, b), while the imagery on the other two focuses on human figures, land animals, birds, and mythological beings (15c, d). The outer band on disk 15a shows reed boats, each with two occupants holding paddles. The third register features spondylus shells on either side of an undulating line that appears to be held by figures in profile. The scene may refer to the spondylus-shell trade with Ecuador.[3] Spondylus shells, and perhaps spondylus divers in cages, are also depicted in the outer band of disk 15b.[4] Spondylus shells, whose natural habitat is the warm waters off the coast of Ecuador, were highly valued in Andean cultures from as early as the second millennium B.C. Because of their appealing colors, ranging from bright orange to purple, they were used in the production of jewelry for the elite. As symbols of water and of the sea, they were important in rituals and are also found placed in burials as offerings.

An unusual feature on disk 15c is the missing right arms of the frontal human figures in the third and fourth registers and the disproportionately large thumbs on their left hands. The meaning of these details is not known. Close examination of disk 15d reveals that the repeat motifs are applied with less consistency than on the other three disks, especially in registers three and four. Also puzzling on this disk is the fact that the rim on two opposite sides was folded over in ancient times, probably to make it fit the slightly oval space.

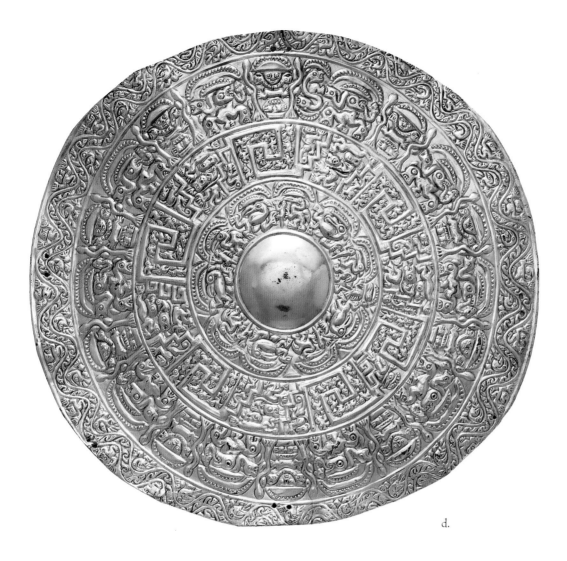

d.

Because none of the disks were excavated, little is known about their archaeological context and suggestions concerning their use are speculative. The known disks all have perforations, usually paired holes, indicating that they were probably once attached to some kind of backing. The number and location of the holes vary. Some scholars believe that they were covers of ceremonial shields.[5] Perhaps they were sewn onto banners or attached to poles and displayed during special rituals.[6]

1. See note for catalogue no. 11. Of the reported twenty-five (?) repoussé disks originally in the group, seven are in public collections in the United States (Detroit Institute of Arts; Dumbarton Oaks, Washington, D.C. [b]; Lowe Art Museum, Coral Gables [a]; National Museum of the American Indian, Smithsonian Institution, Washington, D.C.; Saint Louis Art Museum; and The Metropolitan Museum of Art [c, d]); one is in Finland (Didrichsen Art Museum, Helsinki); one is in a private collection in the United States; and two are in the Museo de Oro del Perú, Lima. The whereabouts of the remaining disks are unknown.

2. For a detailed technical description of disk 15b, see Lechtman 1996b, pp. 220–22.

3. Cordy-Collins 1990, p. 396.

4. Cordy-Collins 1996, pp. 218–20.

5. Tushingham 1976, p. 133, n. 246.

6. Ceremonial banners have been excavated at Sipán; see Alva and Donnan 1993, p. 60. The only other known group of sizable disks in precious metal was excavated at Huaca Loro, Batán Grande, in the La Leche Valley (Shimada 1997, nos. 75–86, fig. 21). The group comprises fourteen gold disks ranging in diameter from 10⅜ to 13⅜ in., all of which have the same chased design of ridges emanating raylike from a plain circle in the center. These disks may have been attached to the backs of imposing headdresses (Carcedo de Mufarech and Shimada 1985, fig. 13).

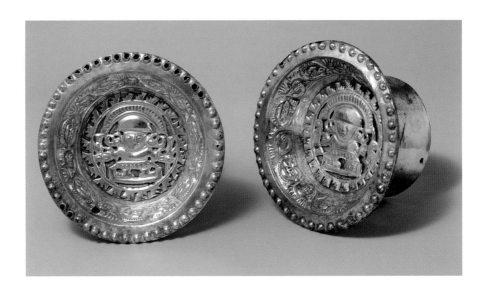

16. Pair of ear ornaments

North Coast. Chimú, 14th–15th century
Silver, gold, diam. 4¾ in. (12.1 cm), length with shaft 2½ in. (6.4 cm)
The Metropolitan Museum of Art, The Michael C. Rockefeller Memorial Collection,
Gift of Nelson A. Rockefeller, 1969 1978.412.188, 189

Nose and ear ornaments have been part of the ritual attire of prominent individuals in Andean cultures since at least the first millennium B.C. and were made of the most precious materials available to the wearer. In the second half of the first millennium A.D., nose ornaments seem to have fallen out of fashion. They were no longer placed in burials, nor were they depicted in art. Ear ornaments, on the other hand, remained popular until the Spanish conquest in the sixteenth century. Those made by the Chimú on the North Coast are often ostentatious and of large size. The shafts on these ornaments are among the thickest known. That they were indeed worn in the extended earlobes is described by the Spaniards, who called the Inka *orejones* (big ears). It is also confirmed by the few surviving silver and gold male figurines from the Inka culture (ca. 1450–1534). These figures have looped lobes hanging on the sides of the face (fig. 16). Only one surviving example shows doughnut-shaped ornaments inserted in the earlobes (fig. 17).

This pair of ear ornaments, very light in weight, is made of sheet silver with concave repoussé frontals crimped to the shafts. In the center is a cutout sheet-gold frontal figure.[1] The combination of gold and silver in the same ornament is also known in Moche metalwork (see cat. nos. 2, 3). The ornaments were held in place with cotton stops (see cat. no. 4).

1. This pair of ear ornaments, as well as a second almost identical pair now in a private collection in Detroit, was part of the large silver finds made in the mid-1960s on the North Coast (see cat. no. 11, n. 1).

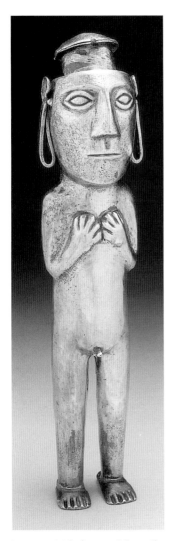

Figure 16. Male figurine. Inka, mid-15th–early 16th century. Silver, height 9 in. (22.9 cm.). Dumbarton Oaks, Washington, D.C.

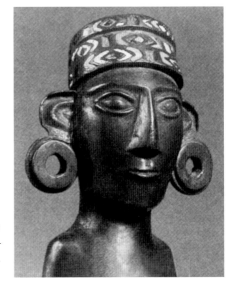

Figure 17. Male figurine with earspools (detail). Inka, mid-15th–early 16th century. Silver, shell inlays, height 7⅝ in. (20 cm). Musée de l'Homme, Paris

17. Necklace with eleven beads (stringing modern)

North Coast. Chimú, 14th–15th century
Silver, max. diam. ca. 2⅛ in. (5.4 cm)
Denver Art Museum

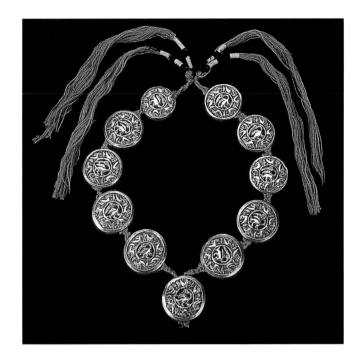

These large beads, executed in delicate repoussé and cut-out work, were probably once part of a grand necklace owned by a high-ranking individual in Chimú society. Each bead is made in two halves, the upper half fitting over the lower. The top is decorated with bird imagery, a frequent theme in Chimú art and architecture. Species identification is often difficult, but the long-beaked birds in the center of each bead are probably cormorants, seabirds that dive deep into the water to catch fish. For many coastal Andean peoples, the sea was not only a source of essential food supplies but also a mythic place where underworld and sea-gods resided. The heads of the birds are turned backward, so that they fit into the small roundels. The central birds are surrounded by six smaller birds in profile. Necklace beads in silver or gold of this size and quality of craftsmanship from the Chimú period are rare. Several examples from the earlier Moche culture (ca. 200–ca. 600), excavated at the site of Sipán, were found on the bodies of elite males.[1]

1. Alva and Donnan 1993, pp. 172, 199, 200.

18. Deer vessel

North Coast. Chimú, 14th–15th century
Silver, height 5 in. (12.7 cm)
The Metropolitan Museum of Art, The Michael C. Rockefeller Memorial
Collection, Gift of Nelson A. Rockefeller, 1969 1978.412.160

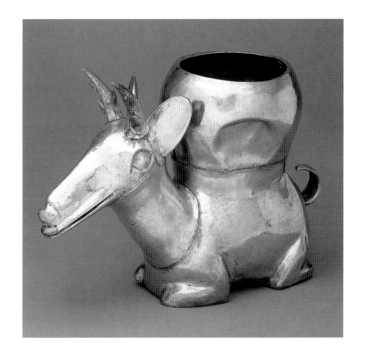

Animal-shaped vessels were made on Peru's North Coast from the second millennium B.C. to the time of the conquest and placed as offerings in the tombs of the honored dead. This charming deer vessel, fabricated at a time when silver production had reached its peak, displays the naturalism that characterizes similar works in ceramic made by the earlier Vicús (ca. 200 B.C.–ca. A.D. 500) and Moche (ca. 200–ca. 800) cultures. It is composed of many separately shaped pieces of sheet silver joined by soldering. Deer are rarely depicted in Chimú art but are a frequent theme in the art of the Moche, in which they were associated with ritual. Rendered naturalistically in hunting scenes, when shown in combat they assumed human characteristics.[1] It is not known whether they had the same meaning in the Chimú culture.

1. Donnan 1997, pp. 51–59.

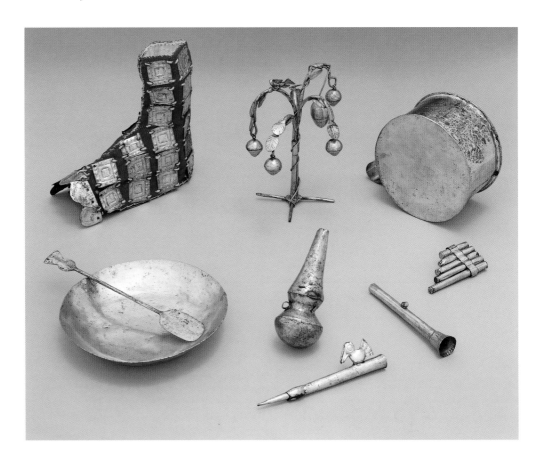

19. Group of miniature objects

North Coast, Chancay Valley. Chimú/Chancay, 13th–15th century
Silver, wood, cotton, camelid hair, feathers, max. height 4¾ in. (12 cm)
The Metropolitan Museum of Art, Bequest of Jane Costello Goldberg, from
the Collection of Arnold I. Goldberg, 1986 1987.394.657, 658, 660–
664, 668, 671, 676–680, 682

In the last centuries prior to the Spanish conquest in the six-teenth century, the peoples on the North Coast buried large numbers of diminutive versions of items that they used in their daily lives. Miniatures of such objects—vessels, musi-cal instruments, items of clothing, tools, weapons, and even flowers and trees—were not children's toys (although some are said to have been found in child burials, as was this group) but votive offerings. One important offering was excavated in the early 1990s at Túcume, near the town of Chiclayo on the North Coast. It contained several hundred miniatures.[1]

The objects illustrated here are said to have been part of a single tomb find of about thirty-five, now in The Metro-politan Museum of Art, made in 1968–69 in the Chancay Valley, north of Lima. Particularly intriguing about the group is the fact that some items are Chimú in style (feathered items and items with cloth), while others are Chancay (the tree and the musical instruments), indicating the contemporaneity of the two styles and the interaction between the North- and Central-Coast peoples.[2]

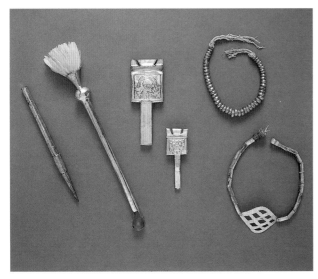

1. Heyerdahl, Sandweiss, and
 Narváez 1995, pp. 111–12.
2. A. P. Rowe 1984, pp. 155–64.

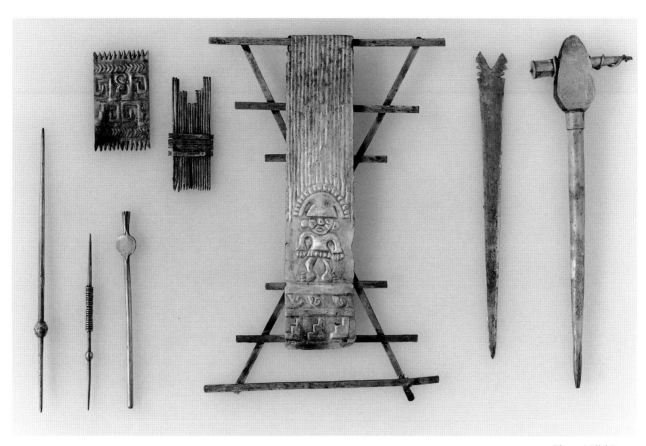

Photo: Hillel Burger

20. Set of miniature spinning and weaving tools

North Coast. Chimú, 13th–15th century
Silver, max. height 6 in. (15.2 cm)
Peabody Museum of Archaeology and Ethnology, Harvard University, Cambridge, Massachusetts

Textiles were of paramount importance in Andean cultures. Made from about the middle of the third millennium B.C., they predated ceramics as a medium of artistic expression by about a thousand years. Primarily of cotton and camelid fiber (hair of the domesticated llama, the alpaca, and the wild vicuña), textiles were used not only for clothing but in ritual and political life. Vast quantities of fine textiles, often brilliantly colored (most dyes derived from plants), were buried with the dead and burned as offerings. Many significant events in the life of an individual or a social group were accompanied by giving or exchanging cloth. From simple finger techniques, such as twining, looping, and knotting in the early beginnings, Andean clothmakers over time invented an extraordinary diversity of weaving methods and textile structures. Textiles in ancient Peru were made mostly by women, and weaving baskets with full-sized implements are often found in women's burials.

The miniature spinning and weaving tools shown here are part of a rare set of about twenty-two pieces. The largest is the X-shaped weaving loom with a partially finished textile showing a standing figure wearing a crested headdress. Also in the group are a spindle, a bobbin, and a pattern pick; a fringed textile; a weaving comb and sword; and a fiber-wrapped cone.

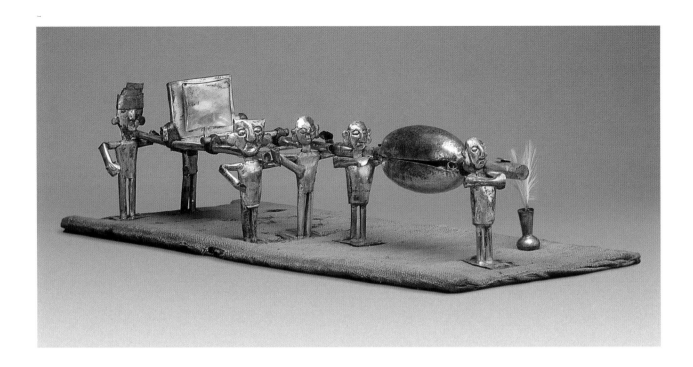

21. Funeral procession

North Coast. Chancay or Chimú, 14th–15th century
Silver, cotton, reeds, feathers, 5 ⅞ x 10 ⅛ x 23 ½ in. (15 x 25.6 x 59.7 cm)
Krannert Art Museum, University of Illinois, Urbana-Champaign

1. Sawyer 1975, pp. 152–63; Morris and von Hagen 1993, p. 184.
2. On the basis of the double warps, the most diagnostic feature of Chimú weaving, the cloth may be attributed to the Chimú (A. P. Rowe 1984, p. 24).

The Chancay culture, which flourished on the Central Coast north of Lima, is noted for the manufacture of groups of doll-like figures made of cloth, which are often engaged in some kind of activity.[1] Conceptually related to these doll groups are three rare miniature models of figural scenes made of silver (see fig. 3 and cat. no. 22). This model shows the funeral procession of an important person, his empty litter carried behind an oval casket on a pole borne on the shoulders of two visibly mournful men. Two small vessels can be seen inside the casket at the front, a reference to the Andean tradition of burying offerings, often in the form of vessels, with the dead. There is a pillow in the coffin but no body, perhaps an indication that the procession is on its way to collect the mortuary bundle of the deceased to take it to its final resting place. Three of the litter bearers, two of whom wear headdresses, have square faces, while the other three have round faces, perhaps a distinction between social rank or ethnic group. The figures, constructed of several pieces of preshaped soldered sheet, wear plain clothes; the round-faced figures also wear ear ornaments. The feet of the two pallbearers are worked in low relief. The figures are sewn to a mat formed of reeds covered with cloth.[2] It is not known in what condition the object was found; marks in the cloth around the bases of the figures indicate that the mat is original. The upper and lower parts of the oval casket show traces of textile impressions, suggesting that it was wrapped in a textile. The crossbeams and long poles of the litter are held with raw cotton covered with purple feathers, probably those of the Paradise Tanager. Similar scenes of litter- and pallbearers are also known in ceramic.

22. Garden scene

North Coast. Chancay or Chimú, 13th–15th century
Silver, 2¼ x 2⅞ x 4 in. (5.8 x 7.3 x 10.3 cm)
Krannert Art Museum, University of Illinois, Urbana-Champaign

This garden scene is probably a tomb offering intended to bring forth rich crops. It shows a human figure standing in an enclosure amid six plants or trees. Embossed serpentine patterns on the ground represent irrigation canals, which were essential to agriculture on the dry desert coast, where this model was found. The plants have been identified as manioc in the center, surrounded by maize and possibly tuna cactus.[1] The cutout figures and plant forms are crimped through slots in the bottom.

1. Bird 1962, p. 178.

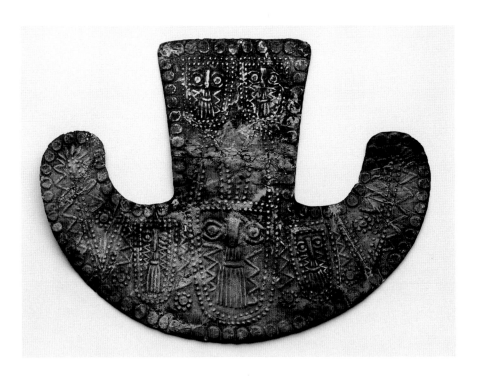

23. Diadem

Far South Coast, Sihuas (?), ca. 2nd century B.C.–ca. 2nd century A.D. (?)
Silver, 12 ¼ x 16 ⅛ in. (31.1 x 41 cm)
The Art Museum, Princeton University

1. McEwan and Haeberli, forthcoming.

Precious metal finds in southern Peru are scarce, perhaps because metal deposits were less abundant and accessible in ancient times than in the north. The South Coast objects are quite distinct in form and surface decoration. This sizable ornament belongs to a group of about twenty that have the same shape and similar overall surface design (none were excavated by archaeologists). All are of sheet gold except for the one illustrated here. The ornaments are usually attributed to the South-Coast Nazca culture (ca. 200–ca. 600). Recent research suggests, however, that they may come from the Camaná and Sihuas Valleys, west of Lake Titicaca, where independent traditions, which are not well understood at this time, flourished.[1] The ornaments may have been worn as diadems attached to turbans or headdresses, although there are no depictions in the art to confirm this. The iconography on the diadems focuses on a stylized oblong face with circular eyes and what appear to be a bearded mouth and zigzag tear lines on the cheeks.

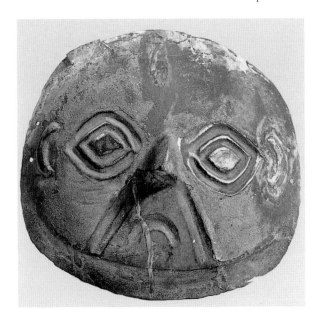

24. Funerary mask

South Coast. Chincha / Ica, 13th–15th century
Silver, cinnabar, 6 x 6 ⅛ in. (15.2 x 15.6 cm)
The Cleveland Museum of Art

Although ideas about death and the afterlife may have varied in Andean cultures, one common belief seems to have been that burial marked the beginning of the deceased's journey to the next world. The dead had to be sustained during this journey, and above all they had to maintain their social status and the identity they held in life by wearing the appropriate clothing

and jewelry.[1] The bodies of the dead were often wrapped or dressed in fine textiles, and masks were placed over the face area or attached as a "false face," of which this is an example. Funerary masks could be of wood, ceramic, fabric, or precious metals.

1. Burger 1997, pp. 30–31.

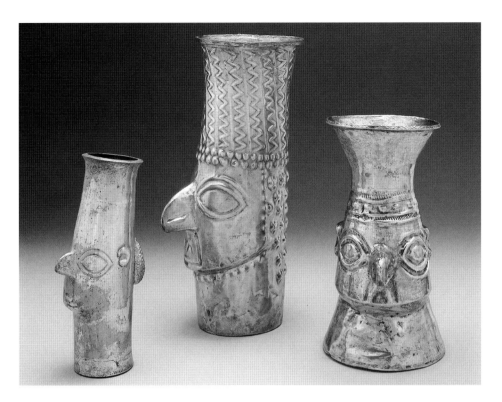

25. Group of face beakers

Central or South Coast. Chincha / Ica / Inka, 14th–early 16th century

Silver, height 6½ in. (16.5 cm); 9¾ in. (24.8 cm); 7¼ in. (18.4 cm)

The Metropolitan Museum of Art, Bequest of Jane Costello Goldberg, from the Collection of Arnold I. Goldberg, 1986 1987.394.318

The Metropolitan Museum of Art, The Michael C. Rockefeller Memorial Collection, Bequest of Nelson A. Rockefeller, 1979 1979.206.1102

Perez Soto Collection

Beakers with human faces on one side made of precious metals were worked in Peru from about the ninth to the early sixteenth century. Those with pronounced noses, resembling bird beaks, are said to have been found in many parts along the Central and South Coasts. Because none were excavated by archaeologists, their cultural attribution is uncertain. In the literature they are variously called Chimú, Chincha, Ica, and Inka. The more naturalistic rendering of the facial features on Chimú beakers, particularly the eyes and noses, would argue against their attribution to that culture (see cat. nos. 10–12).

The beakers are known in all sizes, from two to sixteen inches in height. Some are straight-sided, while others have flared bases and stepped tops (fig. 18). Many were made from a single sheet of silver by hammering the metal over carved wooden molds that are flat in back and held in place by a wedge during hammering (see fig. 12); others have soldered seams along the back and bottom. Although the faces on the beakers are quite standardized, the mouth usually downturned, there is great variety in the depiction of headdresses worked in repoussé. Many have stylized corncobs at the back of the head, in repoussé or attached by soldering, perhaps a reference to the use of such beakers for drinking *chicha*, a fermented corn beer, during rituals.

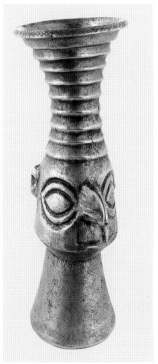

Figure 18. Face beaker. Ica/Inka, 14th–early 16th century. Silver, height 7⅜ in. (18.7 cm.). Dallas Museum of Art

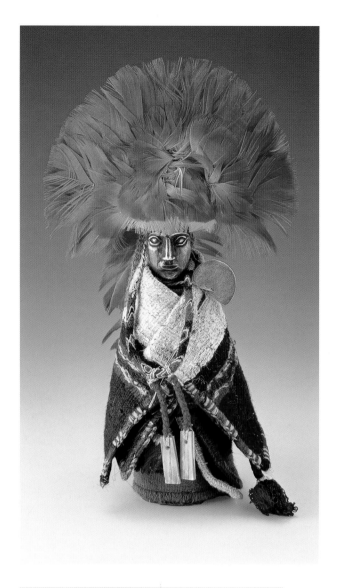

26. Female figure

Chile. Inka, from Cerro El Plomo, early 16th century
Silver, camelid hair, feathers, spondylus shell, height 4 in. (10.2 cm)
Museo Nacional de Historia Natural, Santiago

Small male and female figurines of gold or silver were placed throughout the empire by the Inka as offerings in special burials, often those of child sacrifices and in *huacas*, sites in the landscape considered sacred, such as caves, springs, rocks, and mountain peaks.[1] The figurines were originally dressed in the finest miniature garments, but for those now in museum collections the clothing is missing.[2] This female figurine was discovered in 1954 in a child burial near the mountaintop of Cerro El Plomo, in central Chile, at an altitude of 17,700 feet (5,400 m).[3] Except for the splendid feather headdress, the clothing on the figure is the same worn by Inka women. Under the mantle of fine vicuña wool is a wrapped garment held at the shoulders with *tupus* (one is now missing; see cat. no. 28). A patterned sash with tassels is wound around the waist. The mantle, which has a colorful border, is held with a silver pin called a *tipqui* (also cat. no. 28). The figure was found with the mummy of an interred nine-year-old boy along with several other offerings (fig. 19), including two small llama figures, one of a gold-and-copper alloy, the other of spondylus shell. The high altitude and subfreezing temperatures at the burial site account for the excellent state of preservation of both the mummy and the artifacts.

1. Sacrifices, primarily of llamas and guinea pigs, were an integral part of Inka ritual life. The most valuable sacrifices were of humans. Children in particular were offered only to the most important gods on the most solemn occasions, such as during pestilence or famine, or at the coronation or death of a ruler (J. H. Rowe 1946, pp. 305–12). One elaborate Inka sacrifice involving children was the *capac hucha*; for a description of this ritual, see McEwan and Van de Guchte 1992, pp. 359–71.
2. It is not certain whether some figurines were buried without clothing. Those reportedly found in coastal sites without clothing perhaps had garments originally, but because of occasional rains and exposure to moisture they may have disintegrated over many centuries of burial. All the precious metal figurines found in recent years in very high altitudes in the Andes have been clothed (Reinhard 1992, pp. 84–111; Reinhard 1996, pp. 62–81; Reinhard 1999, pp. 36–55).
3. Mostny 1957.

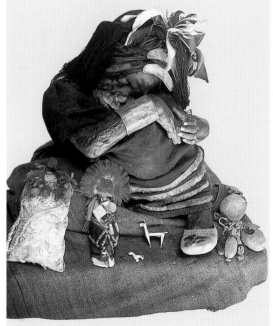

Figure 19. Mummy from Cerro El Plomo, Chile. Inka, ca. 1500. Museo Nacional de Historia Natural, Santiago (photo: Loren McIntyre)

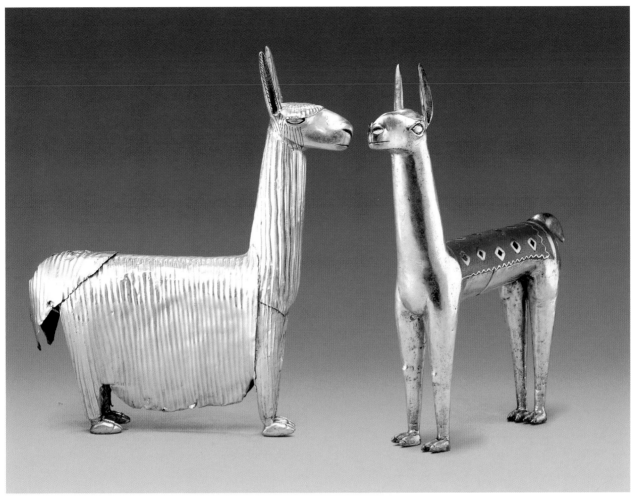

27. Long-haired llama and llama with red blanket

South Highlands. Inka, reportedly from the island of Titicaca, mid-15th–early 16th century
Silver, height 9⅜ in. (23.8 cm); 9 in. (20.3 cm); blanket: cinnabar (modern replacement), gold inlay
American Museum of Natural History, New York

Arguably the finest examples of Inka silversmithing in existence, these sculptures of a long-haired llama and a llama with a red blanket on its back (not in exhibition) were reportedly found near a rock sacred to the Inka, on the island of Titicaca, where they had been placed with other objects as offerings to the gods. The striated, crimped silver sheet of the figure on the left represents the hanging fleece of the long-haired llama, and the Spanish chroniclers reported that the royal llama bore a red blanket on its back. The blanket on the llama on the right has a diamond pattern and a zigzag line of inlaid gold thread. Llamas are highland animals associated with the mountains, considered sacred in Peru because they were the abode of the gods and revered ancestors and the wellspring of the rains. Llamas have been domesticated in the Andes for thousands of years and are the only indigenous pack animals. Important sources of food and fiber, they were also prime sacrificial animals.[1] Even today llama sacrifices are performed on special occasions in highland communities. Small llama figures of silver and gold as well as spondylus shell are also found in sacrificial burials (see fig. 19).

1. J. H. Rowe 1946, p. 306.

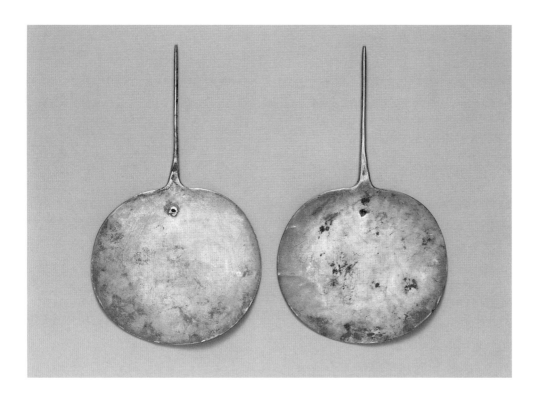

Figure 20. *Coya* (a wife of the Inka) wearing large *tupus*. Drawing by Felipe Guaman Poma de Ayala, *El primer nueva corónica y buen gobierno* (1583–1615), pl. 120

28. Pair of *tupus* (women's dress pins)

South Highlands (?). Inka, mid-15th–16th century
Silver, 6½ x 3⅞ in. (16.5 x 9.8 cm)
Private collection

When the Spaniards arrived in Cuzco, the capital of the Inka empire, in the sixteenth century, they reported that the garments worn by women consisted of two blankets, one of which served as a dress, the other as a cloak. The large square fabric forming the dress was wrapped around the body under the arms and with the edges pulled over the shoulders and fastened with pins called *tupus*. The other blanket was draped around the shoulders, the corners brought together over the chest and closed with a pin called a *tipqui*. The pins, ranging in length from four to eleven inches, were made of gold, silver, or copper; they were the most decorative ornaments worn by Inka women.[1] The dress pins with partial or full disks at the head, as here, were made as pairs and joined by a patterned cord pulled through the holes near the pins. They were inserted through the fabric with the pins pointing upward[2]—as shown in an early-seventeenth-century drawing by Guaman Poma de Ayala (fig. 20)—and secured by wrapping the ends of the cord around the entry and exit points of the pins. Shawl or cloak pins, which are usually shorter, were inserted horizontally.[3] Pairs of *tupus* of this size are rare. Because the woman in Guaman Poma de Ayala's drawing is a *coya* (a wife of the Inka), it is possible that such large pins were worn only by royal women.

Pins continued to be made during colonial times. Those from the transitional period a few decades after the conquest, when indigenous traditions were still strong, combine local features with those of the Spanish culture, as illustrated by a late-sixteenth-century pin (fig. 21). While the shape of the pin is quintessentially Inka, the crescent is embellished with a traced foliage design typical of sixteenth-century Europe.

1. Cobo 1990, pp. 187–89.
2. In 1995, the body of a fourteen-year-old girl was discovered near the peak of Nevado de Ampato, in southern Peru. Known as Juanita, she had been sacrificed to the gods and buried with offerings some five hundred years earlier (for an example of such a sacrifice, see fig. 18). At an altitude of almost 21,000 feet (6,300 m), her body and dress, held with *tupus* at the shoulders, were still well preserved (Bahn 1999, pp. 68–69).
3. For a detailed description of Inka women's dress, see A. P. Rowe 1997, pp. 11–23.

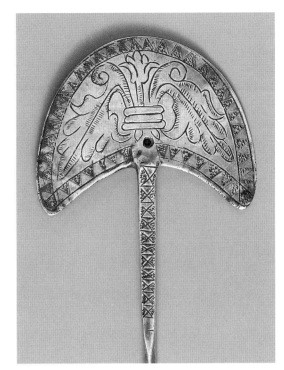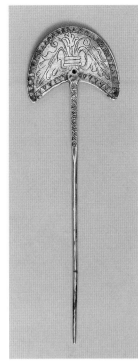

Figure 21. Pin. Colonial, late 16th century (?). Silver, length 7⅞ in. (20 cm). Private collection

29. Male figurine wearing a feather headdress

South Coast, reportedly from Ica. Inka/colonial (?), 16th century
Cast silver, height 3⅛ in. (7.9 cm)
American Museum of Natural History, New York

The small male and female figurines of silver and gold buried by the Inka as votive offerings are usually nude because while originally they were clothed, the garments of cotton and camelid hair have since disintegrated (see cat. no. 26). Made to standard specifications, they were cast or formed of sheet metal. They are usually shown with their hands on their chests (see fig. 16). Males have extended earlobes and wear headbands; females have long straight hair. A small group of cast figurines, such as this example, is shown wearing clothing and holding or carrying objects.[1] This rare figurine wears a long feathered tunic and is crowned with an impressive tall feather headdress. He holds in his right hand a club with a star-shaped mace head and in his left an oval vessel (see cat. no. 30, top). It is not known whether the Inka used these figurines for the same purpose as the ones they dressed in real garments, or whether they were made for special rituals. None have been found by archaeologists. It is possible that they were produced in the early colonial period.

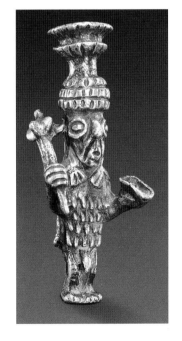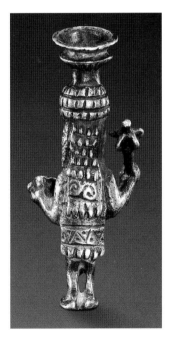

1. Lapiner 1976, p. 316; Carcedo de Mufarech 1997, p. 67.

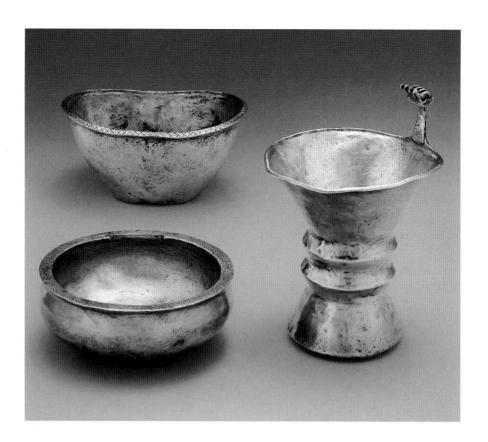

30. Group of vessels

South Coast. Late Ica / Inka / colonial (?), 16th century
Silver, height 2⅛ in. (5.5 cm); 3¼ in. (8.3 cm); 6¾ in. (17.2 cm)
Perez Soto Collection

Among the vessel forms associated with the Inka period are pleasing oval bowls and tall
beakers with a constricted midsection. Vessels with these shapes continued to be produced in
Peru during the colonial period, and it is likely that the vessels illustrated here date from this
era. While ancient silversmiths used thin sheet silver to craft vessels and took care to remove
the hammering marks, these examples are made of thick silver and the tool marks are still
quite visible. Particularly appealing on the oblong bowl with pinched sides (top) is the rim
with chased cross-hatching, a feature often found on Ica/Inka vessels. It has the same shape
as the one held by the figure in catalogue no. 29. The low bowl has chased fish on its rim and
a cutout section for pouring.

Checklist

All objects are of hammered silver unless otherwise noted.

1. Nose ornament [cat. no. 1, top]
North Coast. Salinar (?), 1st century B.C.–
1st century A.D.
Gold, silver, height ⅞ in. (2.2 cm)
The Metropolitan Museum of Art,
Rogers Fund, 2000 2000.6

2. Two nose ornaments [cat. no. 1]
North Coast. Salinar (?), 1st century B.C.–
1st century A.D.
Gold, silver, height 1⅛ in. (2.9 cm),
1⅜ in. (3.5 cm)
Private collection, New York

3. Two nose ornaments
Vicús region. Moche, from Loma Negra,
Piura Valley, 2nd–3rd century
Silver, 5½ x 8¾ in. (14.1 x 22.2 cm)
The Metropolitan Museum of Art,
The Michael C. Rockefeller Memorial
Collection, Gift of Hugh Smith, by
exchange, 1970 1978.412.243, 244

4. Nose ornament with shrimp
[cat. no. 2]
Vicús region. Moche, from Loma Negra,
Piura Valley, 2nd–3rd century
Silver, gold, greenstone, 4¾ x 7¼ in.
(12.1 x 18.4 cm)
The Metropolitan Museum of Art,
The Michael C. Rockefeller Memorial
Collection, Bequest of Nelson A.
Rockefeller, 1979 1979.206.1236

5. Nose ornament [fig. 14]
Vicús region. Moche, from Loma Negra,
Piura Valley, 2nd–3rd century
Gold, silver, 5 x 7½ in. (12.7 x 18.9 cm)
The Metropolitan Museum of Art,
The Michael C. Rockefeller Memorial
Collection, Bequest of Nelson A.
Rockefeller, 1979 1979.206.1223

6. Pair of earflares with condors [cat. no. 3]
Vicús region. Moche, from Loma Negra,
Piura Valley, 2nd–3rd century
Gilt copper, silver, gold, diam. 3 in. (7.6 cm),
length with shaft 3½ in. (8.9 cm)
The Metropolitan Museum of Art,
The Michael C. Rockefeller Memorial

Collection, Bequest of Nelson A.
Rockefeller, 1979 1979.206.1245.1246

7. Pair of earflares with warriors
Vicús region. Moche, from Loma Negra,
Piura Valley, 2nd–3rd century
Gold, silver, gilt copper, diam. 3 in. (7.6 cm),
length with shaft 3¼ in. (8.1 cm)
The Metropolitan Museum of Art,
The Michael C. Rockefeller Memorial
Collection, Bequest of Nelson A.
Rockefeller, 1979 1979.206.1241-2

8. Mask
Central Coast. Wari, reportedly from
Pachacámac, 7th–10th century
Silver, 7 x 8 in. (17.8 x 20.5 cm)
American Museum of Natural History,
New York B/9450

9. Warrior plaque [cat. no. 6]
Wari, 7th–10th century
Silver, 10¼ x 7⅜ in. (26 x 18.7 cm)
The Glassell Collection

10. Pair of earflares [cat. no. 4]
Wari/Tiwanaku, 7th–10th century
Silver, cotton, diam. 3⅜ in. (8.6 cm),
length with shaft 3¾ in. (9.5 cm)
The Metropolitan Museum of Art,
Bequest of Jane Costello Goldberg, from
the Collection of Arnold I. Goldberg, 1986
1987.394.580, 581

11. *Kero* with repoussé figure
Tiwanaku, 7th–10th century
Silver (mineralized), height 4½ in.
(11.5 cm)
The Metropolitan Museum of Art,
Bequest of Jane Costello Goldberg, from
the Collection of Arnold I. Goldberg, 1986
1987.394.578

12. Two ornamental plumes [cat. no. 5]
South Highlands. Wari/Tiwanaku,
reportedly from Pomacanchi, southeast
of Cuzco, 7th–10th century
Silvered copper, height 13⅝ in. (34.8 cm);
15¾ in. (40 cm)
The Art Museum, Princeton University
y1982-27, 29

13. Seven "clamshell" beads (necklace ornaments?)
South Highlands. Wari/Tiwanaku,
reportedly from Pomacanchi, southeast
of Cuzco, 7th–10th century
Silver, max. diam. 1¾ in. (4.5 cm)
The Art Museum, Princeton University
y1982-46

14. Pair of arm or ankle ornaments
South Highlands. Wari/Tiwanaku,
reportedly from Pomacanchi, southeast
of Cuzco, 7th–10th century
Silver, height 4¾ in. (12 cm)
The Art Museum, Princeton University
y1982-36, 37

15. Rattle beaker with face [cat. no. 8]
North Coast. Lambayeque (Sicán),
10th–11th century
Silver, gold, height 5⅜ in. (13.7 cm),
diam. 3⅜ in. (8.6 cm)
American Museum of Natural History,
New York, 41.2/8683

16. Beaker with repoussé frogs
North Coast. Lambayeque (Sicán),
10th–11th century
Silver, height 6 in. (15.2 cm)
Krannert Art Museum, University of
Illinois, Urbana-Champaign 67-29-205

17. Grave lot: Arm ornaments, earspools, drinking cups, shallow dishes, staffs
North Coast, Batán Grande. Lambayeque
(Sicán), 10th–11th century
Height 2½–16½ in. (6.6–42 cm)
Denver Art Museum 1970.303.1-10

18. Double-walled beaker with repoussé scene [cat. no. 7]
North Coast. Lambayeque (Sicán)/Chimú,
14th–15th century
Silver, height 6 in. (15.2 cm), diam. 5½ in.
(14 cm)
Denver Art Museum 1969.302

19. Litter backrest [cat. no. 9]
North-Central Coast. Chimú, reportedly
found in Huarmey Valley, 14th–15th century

Wood, spondylus shell, feathers, silver, cinnabar, 20⅛ x 41⅜ in. (51.1 x 105.1 cm)
Peabody Museum of Archaeology and Ethnology, Harvard University, Cambridge, Mass. 52-30-30/7348

20. Vessel in the form of an outstretched figure [cat. no. 10]
North Coast. Chimú, 14th–15th century
Silver, gold alloy, 4½ x 8 in.
(11.4 x 20.3 cm)
Eugene Chesrow

21. Panpiper vessel [cat. no. 12]
North Coast. Chimú, 14th–15th century
Silver, malachite inlay (right eye, replacement), height 8¼ in. (20.9 cm)
The Metropolitan Museum of Art,
The Michael C. Rockefeller Memorial
Collection, Gift of Nelson A. Rockefeller,
1969 1978.412.219

22. Warrior vessel [cat. no. 11, left]
North Coast. Chimú, 14th–15th century
Silver, height 6⅝ in. (16.8 cm)
The Metropolitan Museum of Art,
The Michael C. Rockefeller Memorial
Collection, Gift of Nelson A. Rockefeller,
1969 1978.412.162

23. Vessel in form of a figure wearing a loincloth [cat. no. 11, right]
North Coast. Chimú, 14th–15th century
Silver, height 7¾ in. (19.7 cm)
The Metropolitan Museum of Art,
The Michael C. Rockefeller Memorial
Collection, Gift of Nelson A. Rockefeller,
1969 1978.412.171

24. Three humpback vessels
North Coast. Chimú, 14th–15th century
Silver, height 5⅝ in. (14.3 cm); 6⅞ in.
(17.5 cm); 7 in. (17.8 cm)
The Metropolitan Museum of Art,
The Michael C. Rockefeller Memorial
Collection, Gift of Nelson A. Rockefeller,
1969 1978.412.174, 172, 173

25. Face beaker
North Coast. Chimú, 14th–15th century
Silver, height 5⅞ in. (15 cm)
The Metropolitan Museum of Art,
The Michael C. Rockefeller Memorial
Collection, Gift of Nelson A. Rockefeller,
1969 1978.412.176

26. Face beaker
North Coast. Chimú, 14th–15th century
Silver, height 7½ in. (19 cm)

The Metropolitan Museum of Art, The
Michael C. Rockefeller Memorial
Collection, Gift of Nelson A. Rockefeller,
1969 1978.412.175

27. Throne vessel with figures [cat. no. 13]
North Coast. Chimú, 14th–15th century
Silver, 9¼ x 6½ x 4⅛ in. (23.5 x 16.5 x 10.6 cm)
The Metropolitan Museum of Art,
The Michael C. Rockefeller Memorial
Collection, Gift of Nelson A. Rockefeller,
1969 1978.412.170

28. Deer vessel [cat. no. 18]
North Coast. Chimú, 14th–15th century
Silver, height 5 in. (12.7 cm)
The Metropolitan Museum of Art,
The Michael C. Rockefeller Memorial
Collection, Gift of Nelson A. Rockefeller,
1969 1978.412.160

29. Dog vessel
North Coast. Chimú, 14th–15th century
Silver, gold, height 5⅛ in. (13.3 cm)
The Metropolitan Museum of Art,
The Michael C. Rockefeller Memorial
Collection, Gift of Nelson A.
Rockefeller, 1969 1978.412.166

30. Goblet with bird
North Coast. Chimú, 14th–15th century
Silver, height 9½ in. (24.2 cm)
Brooklyn Museum of Art 86.224.203

31. Monkey vessel [cat. no. 11]
North Coast. Chimú, 14th–15th century
Silver, height 5¼ in. (13.4 cm)
The Metropolitan Museum of Art,
The Michael C. Rockefeller Memorial
Collection, Gift of Nelson A. Rockefeller,
1969 1978.412.167

32. Owl vessel
North Coast. Chimú, 14th–15th century
Silver, height 6½ in. (16.5 cm)
The Metropolitan Museum of Art,
The Michael C. Rockefeller Memorial
Collection, Gift of Nelson A.
Rockefeller, 1969 1978.412.161

33. Beaker with repoussé [cat. no. 14]
North Coast. Chimú, 14th–15th century
Silver, height 7 in. (17.8 cm), diam. 7½ in.
(19.1 cm)
Denver Art Museum 1969.303

34. Four keros
North Coast. Chimú, 14th–15th century
Silver, height 8 in. (20.3 cm); 7½ in. (19 cm);

11¾ in. (30 cm); 9¼ in. (23.5 cm)
The Metropolitan Museum of Art,
The Michael C. Rockefeller Memorial
Collection, Gift of Nelson A. Rockefeller,
1969 1978.412.178, 180, 181, 185

35. Pair of bowls with repoussé
North Coast. Chimú, 14th–15th century
Silver, diam. 7⅛ in. (18.1 cm); 7¼ in.
(18.4 cm)
The Metropolitan Museum of Art,
The Michael C. Rockefeller Memorial
Collection, Gift of Nelson A. Rockefeller,
1969 1978.412.190, 191

36. Pair of double-bottomed bowls
North Coast. Chimú, 14th–15th century
Silver, diam. 5⅝ in. (14.3 cm)
Perez Soto Collection, New York

37. Pair of bowls with repoussé
North Coast. Chimú, 14th–15th century
Silver, diam. 7¾ in. (19.8 cm)
The Metropolitan Museum of Art, Bequest
of Jane Costello Goldberg, from the
Collection of Arnold I. Goldberg 1986
1987.394.291, 292

38. Repoussé disk [cat. no. 15a]
North Coast. Chimú, 14th–15th century
Silver, diam. 13½ in. (34.3 cm)
Lowe Art Museum, University of Miami,
Coral Gables 88.0159

39. Repoussé disk [cat. no. 15b]
North Coast. Chimú, 14th–15th century
Silver, diam. 13½ in. (34.3 cm)
Dumbarton Oaks, Washington, D.C. B-474

40. Repoussé disk [cat. no. 15c]
North Coast. Chimú, 14th–15th century
Silver, diam. 13½ in. (34.3 cm)
The Metropolitan Museum of Art, Gift
and Bequest of Alice K. Bache, 1966 1977,
66.196.44

41. Repoussé disk [cat. no. 15d]
North Coast. Chimú, 14th–15th century
Silver, diam. 13⅝ in. (34.6 cm)
The Metropolitan Museum of Art,
The Michael C. Rockefeller Memorial
Collection, Gift of Nelson A. Rockefeller,
1969 1978.412.144

42. Pair of ear ornaments [cat. no. 16]
North Coast. Chimú, 14th–15th century
Silver, gold, diam. 4¾ in. (12.1 cm), length
with shaft 2½ in. (6.4 cm)
The Metropolitan Museum of Art,
The Michael C. Rockefeller Memorial

Collection, Gift of Nelson A. Rockefeller, 1969 1978.412.188, 189

43. Necklace with eleven beads (stringing modern) [cat. no. 17]
North Coast. Chimú, 14th–15th century
Silver, max. diam. 2⅛ in. (5.4 cm)
Denver Art Museum 1978.121

44. Group of pins
North Coast. Chimú/Inka, 14th–15th century
Silver, height 8⅝ in. (21.9 cm); 9½ in. (24 cm); 11 in. (28 cm)
The Metropolitan Museum of Art, Bequest of Jane Costello Goldberg, from the Collection of Arnold I. Goldberg, 1986 1987.394.548-551, 556

45. Group of textile ornaments
North Coast. Chimú, 14th–15th century
Silver, max. height 2½ in. (6.4 cm)
The Metropolitan Museum of Art, Gift of Nathan Cummings, 1964
64.228.210–230

46. Set of spinning and weaving tools [cat. no. 20]
North Coast. Chimú, 13th–15th century
Silver, max. height 6 in. (15.2 cm)
Peabody Museum of Archaeology and Ethnology, Harvard University, Cambridge, Mass. 48-37-30/7162-48-37-30/7172

47. Two miniature tunics
North Coast. Chimú, 13th–15th century
Silver, 3½ x 3⅛ in. (9 x 8 cm)
Peabody Museum of Archaeology and Ethnology, Harvard University, Cambridge, Mass. 46-77-30/6873, 46-77-30/6874

48. Group of miniatures [cat. no. 19]
North Coast. Chimú/Chancay, 13th–15th century
Silver, wood, cotton, camelid hair, feathers, max. height 4¾ in. (12 cm)
The Metropolitan Museum of Art, Bequest of Jane Costello Goldberg, from the Collection of Arnold I. Goldberg, 1986 1987.394.657–688

49. Funeral procession [cat. no. 21]
North Coast. Chancay or Chimú, 13th–15th century
Silver, cotton, reeds, feathers, 5⅞ x 10⅛ x 23½ in. (15 x 25.6 x 59.7 cm)
Krannert Art Museum, University of Illinois, Urbana-Champaign 67-29-303

50. Garden scene [cat. no. 22]
North Coast. Chancay or Chimú, 13th–15th century
2¼ x 2⅞ x 4 in. (5.7 x 7.3 x 10.3 cm)
Krannert Art Museum, University of Illinois, Urbana-Champaign 67-29-305

51. Figure with bowls [fig. 3]
North Coast. Chancay or Chimú, 13th–15th century
Silver, 3¼ x 4 x 4¾ in. (8.3 x 10.1 x 12.1 cm)
Krannert Art Museum, University of Illinois, Urbana-Champaign 67-29-304

52. Diadem [cat. no. 23]
Far South Coast. Sihuas (?), ca. 2nd century B.C.–ca. 2nd century A.D. (?)
Silver, 12¼ x 16⅛ in. (31.1 x 41 cm)
The Art Museum, Princeton University y1992-156

53. Funerary mask [cat. no. 24]
South Coast. Chincha/Ica, 13th–15th century
Silver, cinnabar, 6 x 6⅛ in. (15.2 x 15.6 cm)
The Cleveland Museum of Art 1957.396

54. Mummy bundle figure
South Coast. Chincha/Ica, 13th–15th century
Silvered copper, cinnabar, height 9¾ in. (24.7 cm)
The Cleveland Museum of Art 1957.397

55. Bowl with repoussé bird
South Coast. Ica, 13th–15th century
Silver, diam. 5¼ in. (13.3 cm)
Krannert Art Museum, University of Illinois, Urbana-Champaign 67-29-207

56. Bowl with repoussé animal
South Coast. Ica, 13th–15th century
Silver, diam. 5½ in. (13.9 cm)
Perez Soto Collection

57. Pair of ear ornaments with inlays
South Coast. Chincha/Ica (?), 13th–15th century
Silver, stone, shell, diam. 2¼ in. (5.8 cm)
The Metropolitan Museum of Art, Promised Gift of Lucille and Martin E. Kantor

58. Three tweezer pendants
South Coast. Chincha/Ica, 13th–15th century
Silver, max. height 2¼ in. (5.7 cm)
American Museum of Natural History, New York B/9479, B/9783, 41.0/1581

59. Face beaker
North Coast. Chimú/Inka, 15th century
Silver, height 5 in. (12.6 cm)
American Museum of Natural History, New York 41.0/7351

60. Face beaker [cat. no. 25, center]
Central or South Coast. Chincha/Ica/Inka, 14th–early 16th century
Silver, height 9¾ in. (24.7 cm)
The Metropolitan Museum of Art, The Michael C. Rockefeller Memorial Collection, Gift of Nelson A. Rockefeller, 1979 1979.206.1102

61. Face beaker
Central or South Coast. Chincha/Ica/Inka, 14th–early 16th century
Silver, height 9⅜ in. (23.7 cm)
American Museum of Natural History, New York 41.2/7602

62. Three face beakers
Central or South Coast. Chincha/Ica/Inka, 14th–early 16th century
Silver, height 10¼ in. (26 cm); 7¼ in. (18.4 cm); 6¾ in. (17.2 cm)
Perez Soto Collection

63. Face beaker with corn cobs [cat. no. 25, left]
Central or South Coast. Chincha/Ica/Inka, 14th–early 16th century
Silver, height 6½ in. (16.5 cm)
The Metropolitan Museum of Art, Bequest of Jane Costello Goldberg, from the Collection of Arnold I. Goldberg, 1986, 1987.394.318

64. Janus-faced beaker
Central or South Coast. Chincha/Ica/Inka, 14th–early 16th century
Silver, height 8⅞ in. (22.2 cm)
Krannert Art Museum, University of Illinois, Urbana-Champaign 67-29-425

65. Face beaker [fig. 18]
Central or South Coast. Chincha/Ica/Inka, 14th–early 16th century
Silver, height 7⅜ in. (18.7 cm)
Dallas Museum of Art 1967.4

66. Face beaker
Central or South Coast. Chincha/Ica/Inka, 14th–early 16th century
Silver, height ca. 3 in. (7.6 cm)
Brooklyn Museum of Art 36.358

67. Beaker with stepped sides
Central or South Coast. Chincha/Ica/Inka,

14th–early 16th century
Silver, height 6½ in. (16.5 cm)
The Museum of Fine Arts, Houston
90.376

68. Two beakers with stepped sides
Central or South Coast. Chincha/Ica/Inka,
14th–early 16th century
Silver, height 4⅝ in. (11.8 cm); 4⅜ in.
(11.2 cm)
Perez Soto Collection

69. Pedestal bowl
South Coast (?). Inka, 15th–early 16th
century
Silver, height 3⅝ in. (9.3 cm)
Perez Soto Collection

70. Goblet with repoussé felines
South Highlands (?). Inka, 15th–early
16th century
Silver, height 5⅜ in. (13.5 cm)
Krannert Art Museum, University of
Illinois, Urbana-Champaign 67-29-208

71. Female figure [cat. no. 26]
Chile. Inka, Cerro El Plomo, early
16th century
Silver, camelid hair, feathers, spondylus
shell, height ca. 4 in. (10.2 cm)
Museo Nacional de Historia Natural,
Santiago

72. Standing figure [fig. 16]
Inka, mid-15th–early 16th century
Silver, height 9 in. (22.8 cm)
Dumbarton Oaks, Washington, D.C. B-474

73. Three figures
Inka, mid-15th–early 16th century

Silver, height 6¼ in. (16 cm); 2⅜ in.
(6 cm); 2½ in. (6.3 cm)
American Museum of Natural History,
New York B/9608; B/1636; B/9613

74. Long-haired llama [cat. no. 27, left]
South Highlands. Inka, reportedly from
the island of Titicaca, mid-15th–early
16th century
Silver, height 9⅜ in. (23.8 cm)
American Museum of Natural History,
New York B/1619

75. Two llamas
Inka, mid-15th–early 16th century
Cast silver, height 2¾ in. (7 cm); 1½ in.
(3.7 cm)
Private collection, New York

76. Llama
Inka, mid-15th–early 16th century
Cast silver, height 2 in. (5.1 cm)
The Metropolitan Museum of Art, Gift
and Bequest of Alice K. Bache 1974
1977 1974.271.36

77. Two lime spoons
Chimú/Inka, 15th–early 16th century
Silver, length 2¾ in. (7 cm)
American Museum of Natural History,
New York B/9495, B/9499A

78. Lime spoon with seated figure
Inka, mid-15th–early 16th century
Silver, length 3⅛ in. (8.3 cm)
The Metropolitan Museum of Art,
The Michael C. Rockefeller Collection,
Bequest of Nelson A. Rockefeller, 1979
1979.206.1075

79. Pair of *tupus* (women's dress pins)
[cat. no. 28]
South Highlands (?). Inka, mid-15th–
early 16th century
Silver, 6½ x 3⅞ in. (16.5 x 9.8 cm)
Private collection

80. *Tipqui* (shawl pin)
South Highlands (?). Inka, mid-15th–
early 16th century
Silver, length 4¾ in. (12.1 cm)
Private collection

81. Agricultural figure
Inka/colonial (?), 16th century
Cast silver, height 2 in. (5.1 cm)
The Cleveland Museum of Art
1949.562

**82. Male figurine wearing a feather
headdress** [cat. no. 25]
South Coast, reportedly from Ica.
Inka/colonial (?), 16th century
Cast silver, height 3⅛ in. (7.9 cm)
American Museum of Natural History,
New York B/9588

83. Three vessels [cat. no. 30]
South Coast. Late Inka/colonial (?),
16th century
Silver, height 3¼ in. (8.3 cm); 2⅛ in.
(5.5 cm); 6¾ in. (17.2 cm)
Perez Soto Collection

84. Pin [fig. 21]
Early colonial, late-16th century (?)
Silver, length 7⅞ in. (20 cm)
Private collection

Bibliography

Alva, Walter

1994 *Sipán.* Colección Cultura y artes del Perú. Edited by José Antonio de Lavalle. Lima, 1994.

Alva, Walter, and Christopher B. Donnan

1993 *Royal Tombs of Sipán.* Exh. cat., Fowler Museum of Cultural History, University of California, Los Angeles. Los Angeles, 1993.

Bahn, Paul G.

1999 "Frozen in the Past." *Archaeology* 52 (July–August 1999), pp. 68–69.

Bird, Junius B.

1962 "Art and Life in Old Peru: An Exhibition." *Curator* (American Museum of Natural History, New York) 5 (1962), pp. 145–210.

1979 "The 'Copper Man': A Prehistoric Miner and His Tools from Northern Chile." In *Pre-Columbian Metallurgy of South America: A Conference at Dumbarton Oaks, October 18th and 19th, 1975,* edited by Elizabeth P. Benson, pp. 105–32. Washington, D.C., 1979.

Bonavia, Duccio

1994 *Arte e historia del Perú antiguo: Colección Enrico Poli Bianchi.* Arequipa, 1994.

Burger, Richard L.

1992 *Chavín and the Origins of Andean Civilization.* New York, 1992.

1997 "Life and Afterlife in Pre-Hispanic Peru: Contextualizing the Masterworks of the Museo Arqueológico Rafael Larco Herrera." In *The Spirit of Ancient Peru: Treasures from the Museo Arqueológico Rafael Larco Herrera,* edited by Kathleen Berrin, pp. 21–32. Exh. cat., Fine Arts Museums of San Francisco. San Francisco, 1997.

Cabello de Balboa, Miguel

1586 "Miscelánea antártica." MS. Universidad Nacional Mayor de San Marcos, Lima. [Manuscript copies are in the collections of the New York Public Library and the University Library, University of Texas, Austin.]

Carcedo de Mufarech, Paloma

1989 [Paloma Carcedo Muro]. "Anda ceremonial lambayecana: Iconografía y simbología." In *Lambayeque,* pp. 249–70. Colección Arte y tesoros del Perú, Culturas precolombinas. Edited by José Antonio de Lavalle. Lima, 1989.

1997 "La plata y su transformación en el arte precolombino." In Paloma Carcedo de Mufarech et al., *Plata y plateros del Perú,* edited by José Torres della Pina and Victoria Mujica, pp. 17–117. Lima, 1997.

1998 "Instrumentos líticos y de metal utilizados en la manufactura de piezas metálicas conservadas en los museos." *Boletín* (Museo del Oro, Banco de la República, Bogotá), nos. 44–45 (January–December 1998), pp. 241–70.

Carcedo de Mufarech, Paloma, and Izumi Shimada

1985 [Paloma Carcedo Muro]. "Behind the Golden Mask: The Sicán Gold Artifacts from Batán Grande, Peru." In *The Art of Precolumbian Gold: The Jan Mitchell Collection,* edited by Julie Jones, pp. 60–75. Exh. cat., The Metropolitan Museum of Art, New York. Boston, 1985.

Castillo Butters, Luis Jaime, and Christopher B. Donnan

1994 "La ocupación Moche de San José de Moro, Jequetepeque." In *Moche: Propuestas y perspectivas,* edited by Santiago Uceda and Elías Mujica, pp. 93–146. Travaux de l'Institut Français d'Études Andines, 79. Trujillo, 1994.

Centeno, Silvia, and Deborah Schorsch

1996 "Caracterización de depósitos de oro y plata sobre artefactos de cobre del valle de Piura (Perú) en el período intermedio temprano." *Boletín* (Museo del Oro, Banco de la República, Bogotá), no. 41 (July–December 1996), pp. 165–85.

Chávez, Sergio Jorge

1984 "Funerary Offerings from a Middle
–85 Horizon Context in Pomacanchi, Cuzco." *Ñawpa pacha* (Institute of Andean Studies, Berkeley) 22–23 (1984–85), pp. 1–48.

Cieza de León, Pedro de

1959 [1553] *The Incas.* Translated by Harriet de Onís. Edited by Victor Wolfgang von Hagen. The Civilization of the American Indian Series, 53. Norman, Okla., 1959.

Cleveland Museum of Art

1978 *Handbook.* Cleveland Museum of Art. Cleveland, 1978.

Cobo, Bernabé

1990 [1653] *Inca Religion and Customs.* Edited and translated by Roland Hamilton. Austin, 1990.

Cordy-Collins, Alana

1990 "Fonga Sigde: Shell Purveyor to the Chimu Kings." In *The Northern Dynasties: Kingship and Statecraft in Chimor; a Symposium at Dumbarton Oaks, 12th and 13th October 1985,* edited by Michael E. Moseley and Alana Cordy-Collins, pp. 393–417. Washington, D.C., 1990.

1996 "Disk." In *Andean Art at Dumbarton Oaks,* edited by Elizabeth Hill Boone, vol. 1, pp. 218–20. Pre-Columbian Art at Dumbarton Oaks, 1. Washington, D.C., 1996.

Cummins, Thomas Bitting Foster

1988 "Abstraction to Narration: Kero Imagery of

Peru and the Colonial Alteration of Native Identity." 2 vols. Ph.D. diss., University of California, Los Angeles, 1988.

Donnan, Christopher B.

1976 *Moche Art and Iconography.* A Book on Lore, 33. Los Angeles, 1976.

1990 "An Assessment of the Validity of the Naymlap Dynasty." In *The Northern Dynasties: Kingship and Statecraft in Chimor; a Symposium at Dumbarton Oaks, 12th and 13th October 1985,* edited by Michael E. Moseley and Alana Cordy-Collins, pp. 243–74. Washington, D.C., 1990.

1997 "Deer Hunting and Combat: Parallel Activities in the Moche World." In *The Spirit of Ancient Peru: Treasures from the Museo Arqueológico Rafael Larco Herrera,* edited by Kathleen Berrin, pp. 51–59. Exh. cat. Fine Arts Museums of San Francisco. San Francisco, 1997.

Forthcoming "Tumbas con entierros en miniatura: Un nuevo patron funerario Moche." In *Actas del Segundo coloquio de arqueología sobre la cultura Moche,* edited by Santiago Uceda and Elías Mujica. Forthcoming.

Donnan, Christopher B., and Luis Jaime Castillo Butters

1994 "Excavaciones de tumbas de sacerdotisas Moche en San José de Moro, Jequetepeque." In *Moche: Propuestas y perspectivas,* edited by Santiago Uceda and Elías Mujica, pp. 415–24. Travaux de l'Institut Français d'Études Andines, 79. Trujillo, 1994.

Emmerich, André

1965 *Sweat of the Sun and Tears of the Moon: Gold and Silver in Pre-Columbian Art.* Seattle, 1965.

Garcilaso de la Vega, el Inca

1966 *Royal Commentaries of the Incas, and General History of Peru.* Translated by Harold V. Livermore. 2 vols. The Texas Pan-American Series. Austin, 1966.

Grieder, Terence

1978 *The Art and Archaeology of Pashash.* Austin, 1978.

Grossman, Joel W.

1972 "An Ancient Gold Worker's Tool Kit." *Archaeology* 25 (October 1972), pp. 270–75.

Guaman Poma de Ayala, Felipe

1980 [1583–1615] *El primer nueva corónica y buen gobierno.* Edited by John V. Murra and Rolena Adorno. Translated by Jorge L. Urioste. 3 vols. Colección America nuestra, America antigua, 31. Mexico, 1980.

Heyerdahl, Thor, Daniel H. Sandweiss, and Alfredo Narváez

1995 *Pyramids of Túcume: The Quest for Peru's Forgotten City.* London, 1995.

Lapiner, Alan
1976 *Pre-Columbian Art of South America.* New York, 1976.

Lara, Jesús
1980 *La literatura de los Quechuas: Ensayo y antología.* 3rd ed. La Paz, 1980.

Larco Hoyle, Rafael
1941 *Los Cupisniques.* Lima, 1941.
1948 *Cronología arqueológica del norte del Perú.* Buenos Aires, 1948.

Lavalle, José Antonio de
1992 Editor. *Oro del antiguo Perú.* Colección Arte y tesoros del Perú. Lima, 1992.

Lechtman, Heather
1977 "Style in Technology—Some Early Thoughts." In *Material Culture: Styles, Organization, and Dynamics of Technology,* edited by Heather Lechtman and Robert S. Merrill, pp. 3–20. Proceedings of the American Ethnological Society, 1975. St. Paul, 1977.
1984 "Andean Value Systems and the Development of Prehistoric Metallurgy." *Technology and Culture* 25 (January 1984), pp. 1–36.
1988 "Traditions and Styles in Central Andean Metalworking." In *The Beginning of the Use of Metals and Alloys: Papers from the Second International Conference on the Beginning of the Use of Metals and Alloys, Zhengzhou, China, 21–26 October 1986,* edited by Robert Maddin, pp. 344–78. Cambridge, Mass., 1988.
1996a "Bimetallic Effigy Spoon: Technical Description." In *Andean Art at Dumbarton Oaks,* edited by Elizabeth Hill Boone, vol. 1, pp. 59–66. Pre-Columbian Art at Dumbarton Oaks, 1. Washington, D.C., 1996.
1996b "Disk: Technical Description." In *Andean Art at Dumbarton Oaks,* edited by Elizabeth Hill Boone, vol. 1, pp. 220–22. Pre-Columbian Art at Dumbarton Oaks, 1. Washington, D.C., 1996.

Lechtman, Heather, Antonieta Erlij, and Edward J. Barry Jr.
1982 "New Perspectives on Moche Metallurgy: Techniques of Gilding Copper at Loma Negra, Northern Peru." *American Antiquity* 47 (January 1982), pp. 3–30.

Lothrop, Samuel K.
1938 *Inca Treasure as Depicted by Spanish Historians.* Publications of the Frederick Webb Hodge Anniversary Publication Fund, 2. Los Angeles, 1938.
1941 "Gold Ornaments of Chavín Style from Chongoyape, Peru." *American Antiquity* 6 (January 1941), pp. 250–62.
1951 "Gold Artifacts of Chavín Style." *American Antiquity* 16 (January 1951), pp. 226–40.

McEwan, Colin, and Maarten van de Guchte
1992 "Ancestral Time and Sacred Space in Inca State Ritual." In *The Ancient Americas: Art from Sacred Landscapes,* edited by Richard F. Townsend, pp. 359–71. Exh. cat. Art Institute of Chicago. Chicago and Munich, 1992.

McEwan, Colin, and Joerg Haeberli
Forthcoming "Ancestors Past but Present: Gold Diadems from the Far South Coast of Peru." In *Precolumbian Gold: Technology, Style and Iconography,* edited by Colin McEwan. Forthcoming.

Makowski, Krzysztof, et al.
1994 *Vicús.* Colección Arte y tesoros del Perú. Lima, 1994.

Means, Philip A.
1931 *Ancient Civilizations of the Andes.* New York, 1931.

Morris, Craig, and Adriana von Hagen
1993 *The Inka Empire and Its Andean Origins.* New York, 1993.

Moseley, Michael E.
1992 *The Incas and Their Ancestors: The Archaeology of Peru.* London, 1992.

Mostny, Grete
1957 Editor. "La momia del Cerro El Plomo." *Boletín* (Museo Nacional de Historia Natural, Santiago) 27, no. 1 (1957).

Muller, Priscilla E.
1985 "The Old World and Gold from the New." In *The Art of Precolumbian Gold: The Jan Mitchell Collection,* edited by Julie Jones, pp. 14–21. Exh. cat., The Metropolitan Museum of Art, New York. Boston, 1985.

Museums of the Andes
1981 *Museums of the Andes.* Great Museums of the World. New York, 1981.

Oehm, Victor P.
1984 *Investigaciones sobre minería y metalurgia en el Perú prehispánico: Una visión crítica actualizada.* Bonner amerikanistische Studien, 12. Bonn, 1984.

Onuki, Yoshio
1995 Editor. *Kuntur Wasi y Cerro Blanco: Dos sitios del formativo en el norte de Perú.* Tokyo, 1995.
1997 "Ocho tumbas especiales de Kuntur Wasi." *Revista de arqueología* (Pontificia Universidad Católica del Perú) 1 (1997), pp. 79–114.

Pease G. Y., Franklin
1995 *Las crónicas y los Andes.* Sección de Obras de historia, Publicación del Instituto Riva-Agüero, 144. Lima, Mexico, and the United States, 1995.

Petersen G., Georg
1970 *Minería y metalurgia en el antiguo Perú.* Arqueológicas, 12. Lima, 1970.

Pillsbury, Joanne
1997 "Kero." In *The Spirit of Ancient Peru: Treasures from the Museo Arqueológico Rafael Larco Herrera,* edited by Kathleen Berrin, p. 189. Exh. cat., Fine Arts Museums of San Francisco. San Francisco, 1997.
Forthcoming "Luxury Arts and the Lords of Chimor." Paper to be published by the Rijksmuseum voor Volkenkunde, Leiden.

Reinhard, Johan
1992 "Sacred Peaks of the Andes." *National Geographic* 181, no. 3 (March 1992), pp. 84–111.
1996 "Peru's Ice Maidens: Unwrapping the Secrets." *National Geographic* 189, no. 6 (June 1996), pp. 62–81.

1999 "Frozen in Time: Children of Inca Sacrifice Found at 22,000 Feet." *National Geographic* 196, no. 5 (November 1999), pp. 36–55.

Ríos, Marcela, and Enrique Retamozo
1982 *Vasos ceremoniales de Chan Chan.* Lima, 1982.

Root, William C.
1949 "The Metallurgy of the Southern Coast of Peru." *American Antiquity* 15 (July 1949), pp. 10–37.

Rowe, Ann Pollard
1984 *Costumes and Featherwork of the Lords of Chimor: Textiles from Peru's North Coast.* Washington, D.C., 1984.
1997 "Inca Weaving and Costume." *Textile Museum Journal* 34–35 (1995–96), pp. 5–53 [published 1997].

Rowe, John Howland
1946 "Inca Culture at the Time of the Spanish Conquest." In *Handbook of South American Indians,* edited by Julian H. Steward, vol. 2, *The Andean Civilizations,* pp. 183–330. Bulletin (Smithsonian Institution, Bureau of American Ethnology), 143. Washington, D.C., 1946.

Sawyer, Alan R.
1975 *Ancient Andean Arts in the Collections of the Krannert Art Museum.* Urbana-Champaign, 1975.

Schorsch, Deborah
1998 "Silver-and-Gold Moche Artifacts from Loma Negra, Peru." *Metropolitan Museum Journal* 33 (1998), pp. 109–36.

Schorsch, Deborah, Ellen G. Howe, and Mark T. Wypyski
1996 "Silvered and Gilded Copper Metalwork from Loma Negra: Manufacture and Aesthetics." *Boletín* (Museo del Oro, Banco de la República, Bogotá), no. 41 (July–December 1996), pp. 145–63.

Shimada, Izumi
1985 "La cultura Sicán: Caracterización arqueológica." In Eric Mendoza Samillán et al., *Presencia histórica de Lambayeque,* pp. 76–133. [Lima?], 1985.
1995 *Cultura Sicán: Dios, riqueza y poder en la costa norte del Perú.* Lima, 1995.
1997 In *Sicán: Ein Fürstengrab in Alt-Peru.* Exh. cat., Museum Rietberg. Zürich, 1997.

Tushingham, A. D.
1976 *Gold for the Gods: A Catalogue to an Exhibition of Pre-Inca and Inca Gold and Artifacts from Peru.* Exh. cat., Royal Ontario Museum. Toronto, 1976.

Uceda, Santiago, et al.
1994 Uceda, Santiago, Ricardo Morales, José Canziani, and María Montoya. "Investigaciones sobre la arquitectura y relieves polícromos en la Huaca de la Luna, valle de Moche." In *Moche: Propuestas y perspectivas,* edited by Santiago Uceda and Elías Mujica, pp. 251–303. Travaux de l'Institut Français d'Études Andines, 79. Trujillo, 1994.